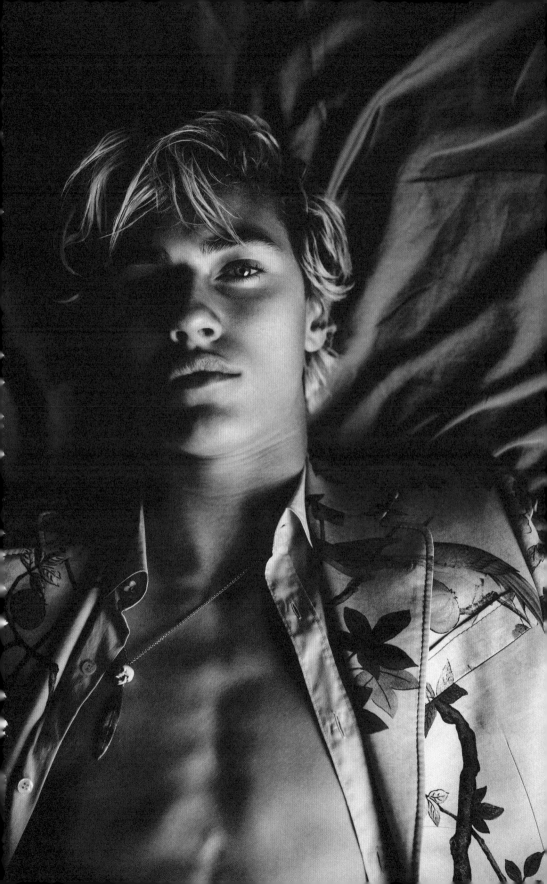

Stay golden

LUCKY BLUE SMITH

WRITTEN WITH DALLON G. SMITH

BANTAM PRESS

LONDON · TORONTO · SYDNEY · AUCKLAND · JOHANNESBURG

TRANSWORLD PUBLISHERS
61–63 Uxbridge Road, London W5 5SA www.penguin.co.uk

Transworld is part of the Penguin Random House group of companies whose addresses
can be found at global.penguinrandomhouse.com

Penguin
Random House
UK

First published in Great Britain in 2016 by Bantam Press an imprint of Transworld Publishers

ISBNS 9780593077764
 9780593077757

Designed and typeset by Smith & Gilmour
Printed in Italy by Printer Trento S.r

Penguin Random House is committed
and our planet. This book is made f

MIX
Paper from
responsible sources
FSC FSC® C018179
www.fsc.org

1 3 5 7 9 10 8 6 4 2

PICTURE CREDITS
Every effort has been made to obtain the necessary permissions with reference to
copyright material. We apologize for any omissions in this respect and will be pleased
to make the appropriate acknowledgements in any future edition.

All photographs provided courtesy of the author unless otherwise stated.

Half title: © Mitchell Nguyen McCormack. Pages 6, 7, 36 and 130: © Jorden Keith. Pages 12, 52,
184–185 and 216: © Dani Brubaker. Page 56: © Tabatha Fireman/Stringer/Getty. Page 71: © Ryan
Astamendi. Page 73 and 236: © NEXT Management. Page 74: © Hedi Slimane. Page 80: Top
© Jacques Dequeker. Pages 82–83 and 87: ©Peggy Sirota. Page 101: © Jozef Ezra. Page 104:
© Patrea Marolf. Page 106 (top) and 109: © Brooke Downey. Page 162: © The Ellen Show. Pages
164-167: © John Urbano. Pages 170-182: © Michael The Maven. Page 190: © Venturelli/
Contributor/Getty. Page 206: © Joe Schildhorn/Philipp Plein. Pages 210-211 and 214: © Michael
Dumler. Page 213: © Sebastian Kim. Page 219: © Business of Fashion. Pages 220 and 225: © David
M. Benett/Getty. Page 222: © Jack Taylor/Stringer/Getty. Page 226: Top left © Vogue Paris/Mario
Testino; top right © DSection/Matthew Brookes; middle left © 10 Magazine/Magnus Unnar
(styled by Garth Spencer); middle right © Vogue Man Ukraine/Lukasz Pukowiec; bottom left
© Wonderland/Christian Oita; bottom right © Harper's Bazaar China/David Roemer. Page 227:
Top left © Rollacoaster/Doug Inglish; top right © CR Men's Book/Sebastian Faena; middle left
© ODDA/Diego Villarreal; middle right © GQ Style Turkey/Sergi Pons; bottom left © Vogue
Spain/Nico Bustos (styled by Belén Antolin); bottom right © Harper's Bazaar Thailand/Lukasz
Pukowiec. Page 228: © Damien Neva. Pages 230 and 233: © L'Oréal Paris.

Cover photograph: Jorden Keith

CONTENTS

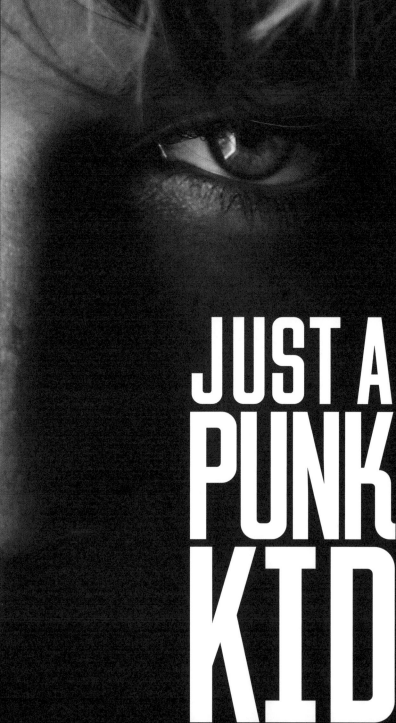

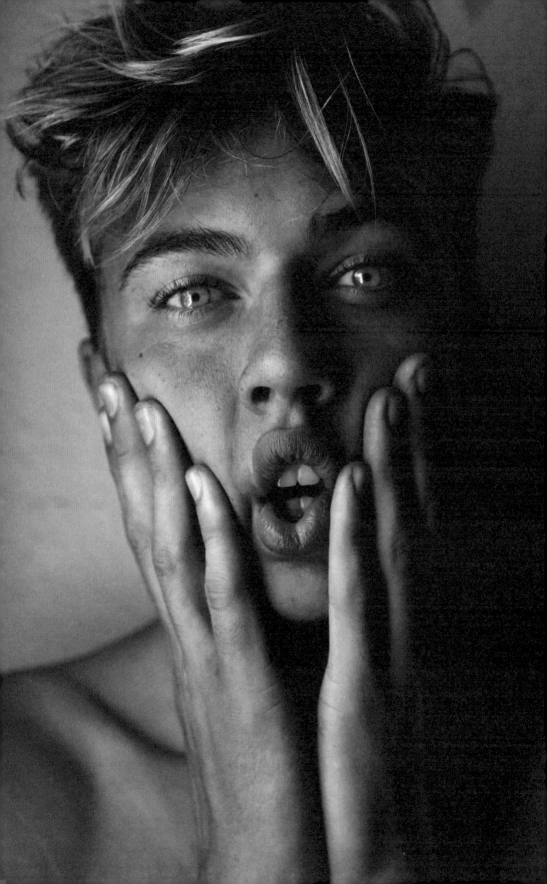

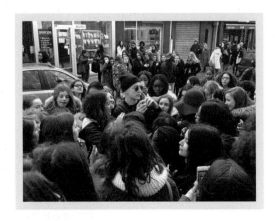

have to admit, I was caught a little off guard when I turned to see about 80 girls running full speed straight at me. I was suddenly swarmed by cute French girls grabbing me, touching me, and hugging me. I looked over to my mom, who had been pushed out of the way. She was wide eyed and amazed at what was happening. The rush was crazy. I was shocked. I wasn't sure what to do. Girl after girl was pushing her way to get close to me, asking me questions, and touching me all over. It was awkward, crazy, fun, uncomfortable, and exciting all at the same time. It was completely overwhelming. I tried my best to answer questions and understand what they were saying, but it was just plain wild.

IT WAS AWKWARD, CRAZY, FUN, UNCOMFORTABLE, AND EXCITING ALL AT THE SAME TIME

One girl, who looked a little worried, finally got my attention and asked if I could help calm her friend down. I walked over to where she was sitting on some steps near the group. She was breathing hard and crying, so I bent down and asked if she was ok. We talked for a minute, and I tried to make her feel better. We took a couple pictures and I gave her a hug. When I let go from the hug, she completely passed out right in front of me! Wow, I didn't know what to think or do about that.

I didn't know at the time, but the police were on their way over to see what was going on. I couldn't understand what the police were saying, but they definitely wanted to

kick us out of the park. As the number of girls increased, we walked over to the street. It started to get a little crazier with the traffic being held up and everyone wondering what was going on.

Just a couple hours earlier, I had been doing an interview in a small café with *The Business of Fashion* magazine. At one point in the meeting, the interviewer asked me about my 'meet ups'. They are something I love doing. Sometimes they are planned with a couple days' notice, or sometimes they are planned that same day. I'll tell fans where I will be at a certain time so I can meet them. I love meeting new fans and friends, especially in foreign countries or places I have never been before. I never want people to feel like I am untouchable or unapproachable. I love my fans!

I was telling *The Business of Fashion* journalist about the meet ups when he suddenly said, 'Hey, why don't you try to do one right now? We can see you in action and take some pictures.' I thought that might be a pretty cool idea, but I really didn't think it would work because there was hardly any time to let people know. So I said, 'Sure, let's try it and see what happens.' I did a quick post on Instagram saying that I was going to be at the Jardin des Tuileries in about an hour. Honestly, I didn't think anyone would show up. Little did I know!

When we finally left the park and went on the street, it started to feel like everything was getting out of hand. More and more people were making their way over to the crowd. The guys from the magazine realized it was getting too crazy, so they got us in the car and we took off. We all looked back, glanced at each other, and just shook our heads in disbelief.

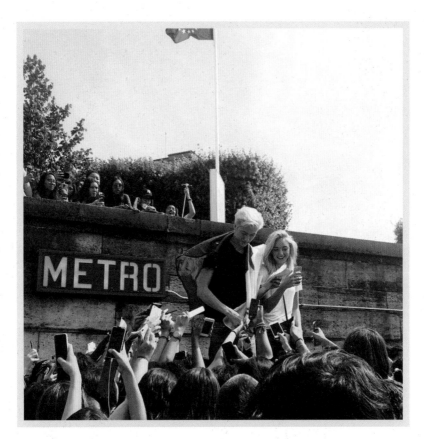

THIS IS DAISY AND ME IN PARIS DURING SPRING/SUMMER
MEN'S FASHION WEEK IN JUNE 2015. I STILL CAN'T GET OVER
HOW MANY PEOPLE WANTED TO MEET US. I HAVE THE BEST FANS.

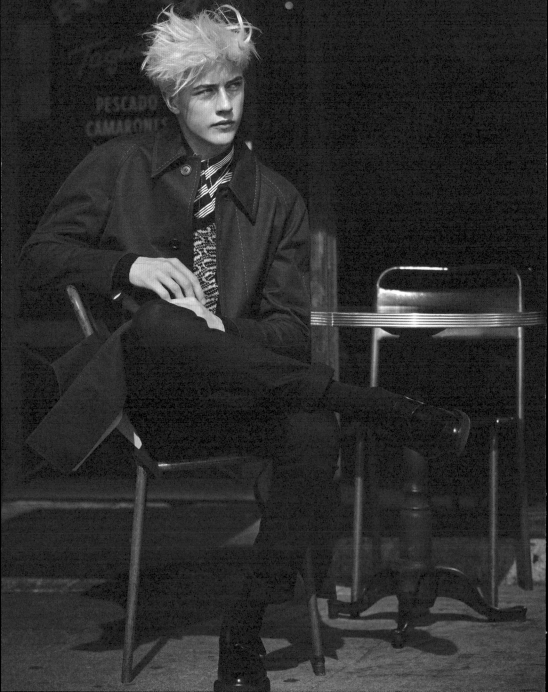

So here I was, barely 16 years old, just a punk kid, hardly any experience in life, traveling the world, meeting legendary people in the arts and fashion world, and making, ohhhh let's just say, a little more money than your average 16-year-old bagging groceries. I couldn't help but think . . . What is going on? How did I get here? How did this happen to me?! Well, let's go back a few years to the beginning.

Before I go there, though, I need to say that everything I have going on in my career is an enormous blessing. I am very grateful and so lucky to have all these opportunities. I'm probably even more fortunate than I realize. I never want to come across as arrogant or cocky. I like to be confident, but there is a major difference to being confident and arrogant. I hope always to be worthy and deserving of these great things that are happening to me.

I HOPE ALWAYS TO BE WORTHY AND DESERVING OF THESE GREAT THINGS THAT ARE HAPPENING TO ME

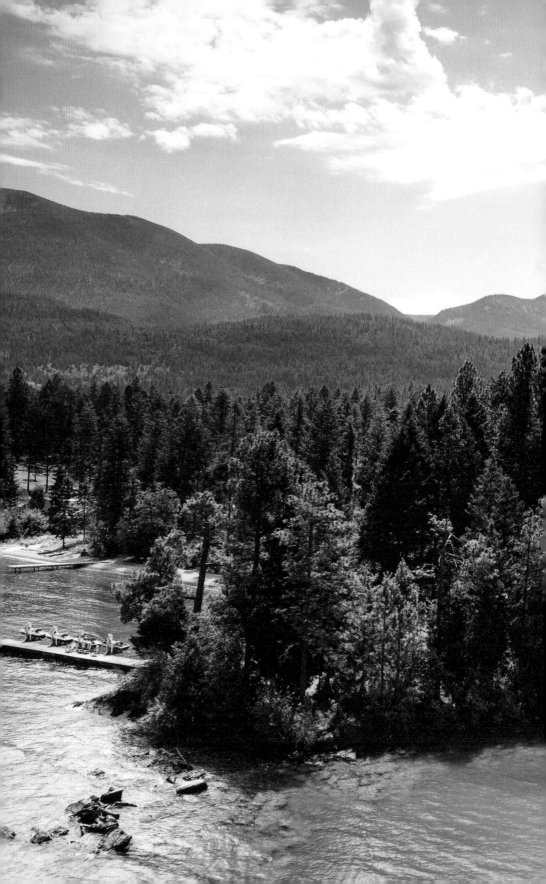

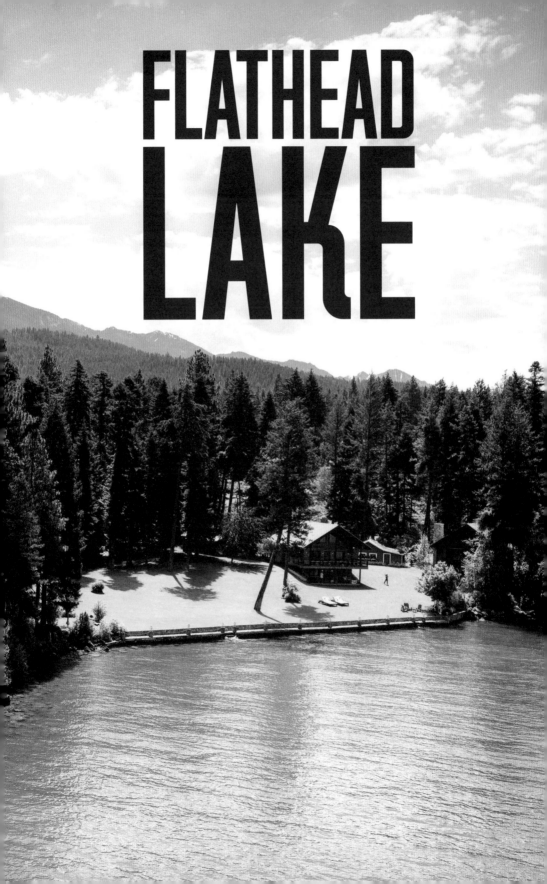

FLATHEAD
LAKE

was born on June 4, 1998, in Salt Lake City, Utah. My parents wanted to be surprised, so they decided on two names, one for a girl and one for a boy. Somehow, the name Lucky made its way on the running list. When my parents asked friends and family what they thought of the name Lucky, most people didn't think they were serious. Some thought it would be a great name for a dog or horse. But, now, no one can imagine anything else. And the name Blue just sounded cool. So that was it.

When I was around two years old, my family moved to California. My dad got a job opportunity out there, so we moved to Orange County. That's where I was introduced to the beach. And I've loved it ever since. I have so many great memories of going to the beach with my family. Most of the time we would go to T-Street beach in San Clemente. My favorite thing to do was stand on my boogie board near

MY FAVORITE THING TO DO WAS STAND ON MY BOOGIE BOARD NEAR THE WATER AS THE WAVES CRASHED ON THE SHORE

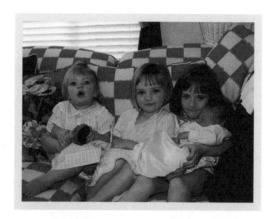

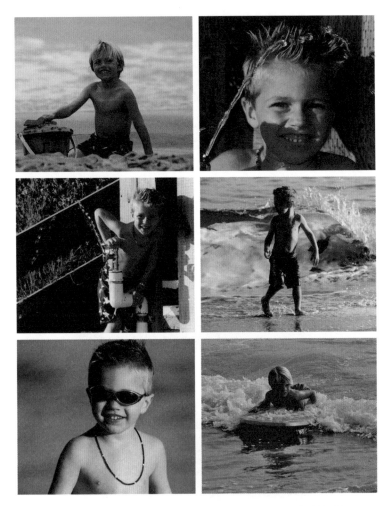

THESE PHOTOS WERE TAKEN WHEN WE LIVED IN ORANGE COUNTY, CALIFORNIA. AFTER WE MOVED AWAY I WOULD RANDOMLY ASK MY MOM AND DAD IF WE COULD MOVE BACK.

the water as the waves crashed on the shore. The waves would lift my board up and I'd do my best not to fall off. I loved to watch the surfers and copy what they were doing. T-Street was great because of the low tides. You could walk out pretty far and it stayed really shallow. My sisters and I also made countless sand castles. I really loved to play with my sisters in the sand. According to my mom, I cried whenever it was time to go home.

ACCORDING TO MY MOM, I CRIED
WHENEVER IT WAS TIME TO GO HOME

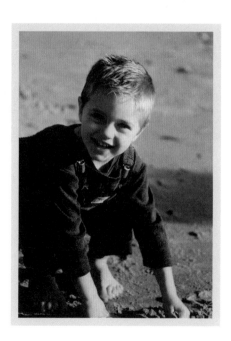

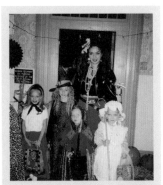
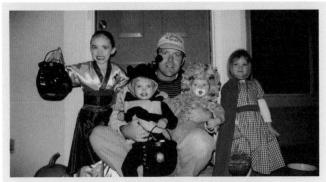

TOP LEFT: LUCKY THE LION.
TOP RIGHT: DAISY THE 1950S GIRL, STARLIE THE FUNKY WITCH,
LUCKY THE KNIGHT IN SHINING ARMOR, MOM AS MADONNA, AND PYPER
AS LITTLE BO PEEP.
BOTTOM: STARLIE MULAN, PYPER THE BUSY BEE, LUCKY LION AND
DAISY RED RIDING HOOD.

MY MOM ALWAYS USED TO MAKE THE BEST HALLOWEEN COSTUMES FOR US
AND MY DAD ALWAYS MADE SURE WE GOT TO TRICK OR TREAT AND GET
LOTS OF CANDY.

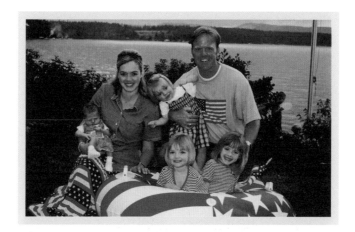

HERE I AM DOING MY VERY FIRST FOURTH OF JULY AT FLATHEAD LAKE.
I'M SO SMALL YOU CAN BARELY SEE ME – JUST ONE MONTH OLD.

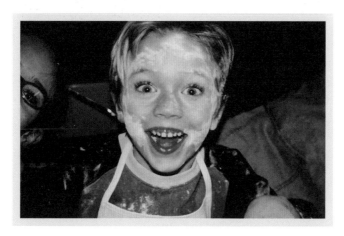

MY MOM WOULD MAKE SUGAR COOKIES WITH US A LOT GROWING UP. I'M
SURE WE GOT MORE FROSTING AND FLOUR ON US THAN ON THE COOKIES
BUT WE ALWAYS HAD FUN TOGETHER.

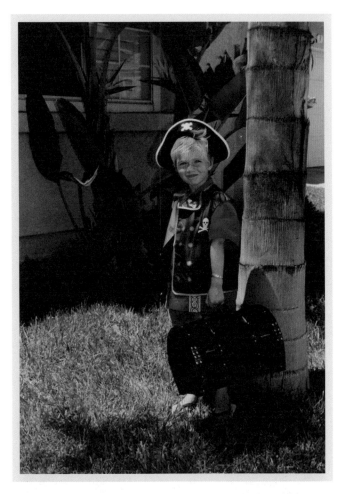

YOUR GOLDEN BIRTHDAY IS WHEN YOU TURN THE AGE OF YOUR BIRTH
DATE. MY BIRTHDAY IS JUNE 4TH SO MY GOLDEN BIRTHDAY WAS WHEN
I TURNED FOUR. MY MOM AND DAD PLANNED A PIRATE PARTY FOR
ME. WE DID ALL KINDS OF FUN THINGS. THEY MADE A REALLY COOL
TREASURE MAP WITH BURNT EDGES AND THAT CHEST I'M HOLDING HAD
ALL KINDS OF CANDY, GOLD COINS AND OTHER PIRATE TREASURES
INSIDE. I STILL HAVE THAT CHEST AND NOW I KEEP SPECIAL
TRINKETS AND KEEPSAKES IN IT, YOU KNOW, THE STUFF YOU JUST
DON'T WANT TO THROW AWAY BECAUSE IT'S A COOL MEMORY OR
MEANS SOMETHING TO YOU.

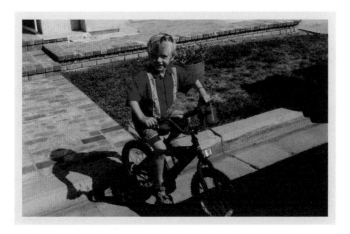

I ALSO GOT MY FIRST TWO-WHEEL BIKE FOR MY GOLDEN BIRTHDAY.
IT WAS A BIG DAY FOR A FOUR-YEAR-OLD KID.

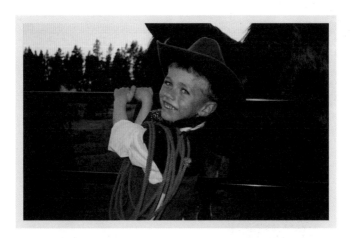

WHEN I TURNED FIVE MY MOM ASKED ME WHAT KIND OF BIRTHDAY I
WANTED TO HAVE. I CHOSE A COWBOY BIRTHDAY SO MY PARENTS GOT
ME THE FULL SET UP – A HAT, VEST, CHAPS, BOOTS, SPURS, ROPE,
AND A HOLSTER WITH CAP GUNS. BIRTHDAYS ARE ALWAYS FUN AT MY
HOUSE – NO MATTER WHAT OUR MONEY SITUATION, MY MOM AND DAD
ALWAYS DID EVERYTHING THEY COULD TO MAKE US FEEL SPECIAL
ON OUR BIRTHDAYS. YOU DON'T NEED MONEY TO MAKE SOMEONE FEEL
LOVED, SPECIAL, AND TO CELEBRATE THEM.

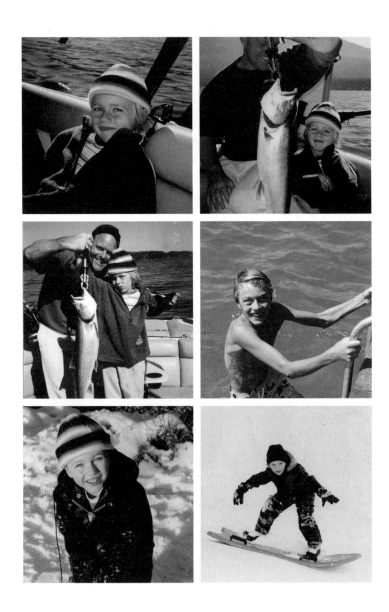

A couple years later, my family packed up and moved again. My dad decided to start a business that he could run from home. In order to save money, we moved to Polson, Montana, to my grandparents' lake house on Flathead Lake. This was where my family had gone on vacation every year since before I was born. Flathead Lake is practically in my blood! It's the most incredible place to stay for the summer – so many fun things to do.

But this time it was different. We now lived in Montana all year. Spring, summer and fall were perfect, and the winter was very cold and long. But I loved living there. It was so beautiful and peaceful. We were about 10 miles from the nearest town, so we were pretty much by ourselves out in the woods. I remember things like helping my dad chop firewood and stacking it on the porch, sledding in the snow, and finding our Christmas tree in the woods. Looking back, one of the best things that living in Montana gave me was quality time with my family. My sisters were my best friends. I did everything with them. I loved them so much, and I knew they loved me. Yeah, in some ways we have normal sibling relationships and fight once in a while, but our bond and love for each other is very strong. And it will be forever. I will always remember that very special time on Flathead Lake.

After a couple years in Montana, the next phase was back to Utah, elementary school, new friends, and drumsticks...

MY SISTERS WERE MY BEST FRIENDS.
I DID EVERYTHING WITH THEM

FIRECRACKERS
& SLINGSHOTS

guess life was pretty much normal for me as a kid in Spanish Fork, Utah. I did the usual stuff like elementary school, birthday parties, and playing with friends. I am a Mormon, so there was always some kind of youth activity going on, along with going to church every week. People at church have always been very nice and kind to me. It's been great to grow up in the Mormon community. I know there are many misconceptions out there about Mormons, but basically we are Christians and we try to follow the example of Jesus in our lives. Mormons like to help other people. I have felt a lot of happiness in my life by helping and serving others, without expecting something in return. It's a great way to live.

You can definitely say I was a typical boy growing up. I loved firecrackers, ball sports, slingshots, knives, guns, and all the usual boy stuff. I was always involved in playing some kind of sport when we were living in Utah. I took part in basketball, football, wrestling, soccer, and athletics. Football was probably my favorite. I was always receiver or safety. I can run like the wind. There was also a pretty good wrestling community in Spanish Fork and I started wrestling when I was around eight years old. There was some kind of tournament every week, and most of the kids in my weight class had already been doing it for a while, so I got my butt kicked a lot the first year. But I kept working hard, and eventually started winning most of my matches.

I actually learned a lot of good things about life through wrestling. I learned how to fight to win, and I learned how to handle things when they don't go your way. With wrestling, it's only you on the mat. There are no other teammates and you can't hide behind someone else. You either make it happen, or you don't. I learned that it's ok to

I PLAYED BASEBALL FOR ONE SEASON - IT JUST WASN'T MY
THING. I USED TO STAND IN THE OUTFIELD AND HOPE THE BALL
WOULD COME MY WAY. I WANTED TO QUIT BUT MY MOM SAID I'D
MADE A COMMITMENT TO THE TEAM AND SO I NEEDED TO STICK
IT OUT. MY COACHES AND THE REST OF THE TEAM CALLED ME
LUCKY CHARM. I DIDN'T REALLY LIKE IT BUT IT'S KIND OF
FUNNY BECAUSE NOW MY FANS CALL THEMSELVES LUCKY CHARMS
AND I THINK IT'S COOL.

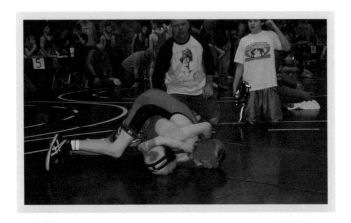

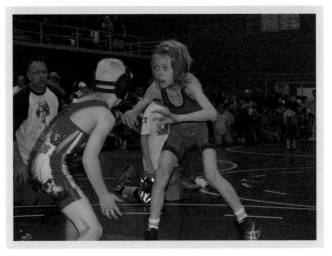

THIS IS ME IN ONE OF MY WRESTLING MATCHES. MY DAD IS IN THE
BACKGROUND ON THE SIDELINES. HE ALWAYS CAME TO MY MATCHES TO
SUPPORT ME. MY MOM AND SISTERS WOULD COME, TOO. THEY USED TO
WEAR SHIRTS, SOCKS OR JACKETS THAT SAID LUCKY ON THEM. IN MY
FAMILY WE ALWAYS SUPPORT EACH OTHER.

be mean and tough and 'all business' during a match but, after it's over, you can be best friends with your opponent. I also learned good sportsmanship. It's not always easy to shake hands when you lose. But, win or lose, you always go shake the hand of your opponent and his coaches. No matter what, it's important to recognize someone else's success and give them credit. I think this attitude has actually helped me in my career today. At the end of every modeling shoot or job, I do my best to walk around and shake everyone's hand and thank all the crew members.

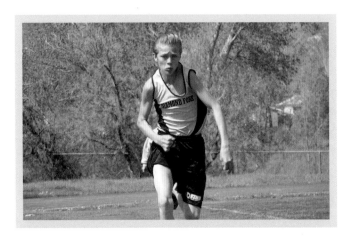

I RAN TRACK FOR MY MIDDLE SCHOOL, DIAMOND FORK JUNIOR
HIGH. I STARTED OUT WITH SHORT SPRINTS BUT MY MOM TALKED
ME INTO TRYING THE 400M. I LOVED DOING THE 200M MEDLEY
RELAY. I TRIED OUT FOR THE LONG JUMP AND THE FIRST TIME
I TRIED THE HIGH JUMP I MADE IT TO THE REGIONAL FINALS.
I WAS HAPPY TO TRY MOST OF THE EVENTS. I ENDED UP BEING
PRETTY GOOD AT THE 400M.

I PLAYED FOOTBALL FOR SEVERAL YEARS AND LOVED IT. I
STARTED OUT WITH FLAG FOOTBALL BUT WHEN I WAS OLD ENOUGH
I ALSO PLAYED TACKLE. MY TRACK SKILLS CAME IN HANDY –
I WAS USUALLY ONE OF THE FASTEST ON MY TEAM. I MADE A
LOT OF GREAT FRIENDS THROUGH FOOTBALL AND LEARNED A LOT
ABOUT BEING ON A TEAM AND WORKING WITH OTHER PEOPLE.

MRS TIFFANY TAYLOR It's weird, but
I actually remember the first time I saw Lucky. I was
coaching an after-school track club and he and his sister,
Pyper, had just joined. We were running laps and the
two of them flew past – Lucky is a very fast runner. They
both had long blond hair and looked like California surfer
kids. You could tell they were best friends and that they
had a wonderful bond. You also could tell they were
confident and secure. They didn't look exactly like the rest
of the kids and yet no one questioned it. Instead, I felt that
more people were drawn to them. They were accepting
and friendly to everyone.

Two years after this, I had Lucky in my class. He was
a great kid. His look had changed a little – it wasn't
California surfer anymore, it was more 1950s. He'd cut
his hair and wore it slicked back, and he usually wore
a leather jacket and rolled-up jeans. He beat to his own
drum, literally and figuratively. Figuratively, his look was
different, but he wore it with confidence and was very
secure in himself. He had lots of friends and was very
funny. In a literal sense, Lucky was ALWAYS drumming.
He would use his fingers or pencils and drum on desks,
chairs, or anything he could find. I quickly realized that he
focused best when he was drumming. Once we were in the
computer lab taking the end of year test. I could tell he was
concentrating hard and, of course, he was drumming on
the table. I knew if I asked him to stop it would break his
concentration, but I also knew his drumming was
disruptive to those around him. I quietly went over and
asked him to walk to my co-worker's room to borrow one
of her stress balls. When he returned, I had him squeeze
the stress ball while he took the test so he could concentrate
but still have some rhythm. It worked great!

MY
FAMILY

The best part of my life is my family. When I was born, Starlie, the eldest, was only four years old. So, all four of us kids are very close in age. My sisters are so supportive of me, and everyone helps me stay grounded. I can't really imagine life without them. We all love each other very much. Sure, no family is perfect, including mine, but I think my family is great. Not only are we a typical family who do normal things together, but with all the modeling, music, acting and everything we do, we're also a family business. We travel the world together, work together, play music together, and grow together. When I have my own family one day, I hope everyone will be just as close as we are.

WHEN I HAVE MY OWN FAMILY ONE DAY,
I HOPE EVERYONE WILL BE JUST AS CLOSE
AS WE ARE

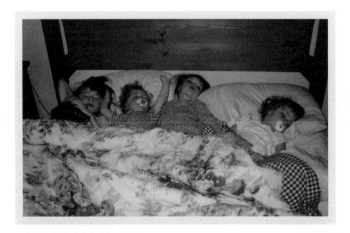

TOP: THIS IS A CLASSIC PICTURE OF ME AND MY SISTERS. WE USED
TO HAVE SNUGGLE FESTIVALS IN MY MOM AND DAD'S BED WITH EVERY-
ONE PILING IN ON SATURDAY AND SUNDAY MORNINGS. I HAVE NO IDEA
HOW Y MOM AND DAD GOT US ALL TO SLEEP AT THE SAME TIME.

BOTTOM: EASTER TIME.

I have great parents. They have a really strong relationship and have been married for 26 years so far. All of us kids feel very, very loved by them. Don't worry, I definitely know how to get in trouble, and have them be not so happy with me once in a while, but I know they love me unconditionally. Over the past three years, at least one of them has traveled with me everywhere I go. I'm sure you can imagine, it might not seem like the coolest thing to have your mom or dad on modeling jobs with you, but I'm glad they are there. It's been good for me. They never hesitate to tell me what I need to hear. They really just want me to be able to chase my dreams, and be smart about it.

Being a Mormon kid in the heart of this whole fashion world has been quite an experience – it hardly fits with the typical Mormon standards like no smoking, no drinking, conservative values and modesty. My parents are very cool with it, but they always remind me to have high standards, be true to myself, and that it's ok to be in the world, but I don't have to be of the world.

CHASAI

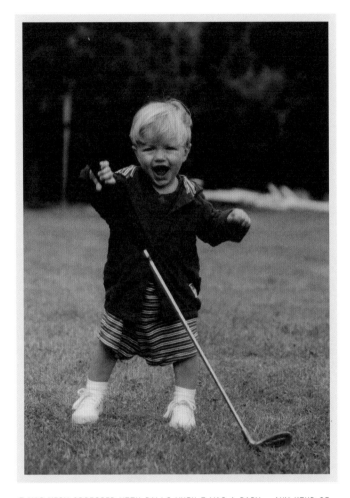

I WAS VERY OBSESSED WITH BALLS WHEN I WAS A BABY – ANY KIND OF
BALL. MY MOM SAYS SHE BOUGHT MORE BOUNCY BALLS OUT OF THE TOY
MACHINES THAN SHE COULD KEEP TRACK OF. WHEN I PASSED A GUMBALL
MACHINE, I'D GO CRAZY BECAUSE I THOUGHT THEY WERE BALLS! SOME
KIDS ARE OBSESSED WITH CARS, BUT I ALWAYS HAD SOME KIND OF
BALL IN MY HAND. IT JUST CHILLS ME OUT AND LETS ME GET MY EXTRA
ENERGY OUT.

I LOVE TO GO HIT GOLF BALLS WITH MY DAD AND I'M LEARNING HOW TO
PLAY. MY DAD TEACHES ME ALL KINDS OF THINGS – HE TEASES ME THAT
HE'S TAUGHT ME EVERYTHING I KNOW.

ONE YEAR FOR VALENTINES MY PARENTS GOT US ALL THESE CUTE
UNDIES WITH A HEART BOX OF CHOCOLATES.

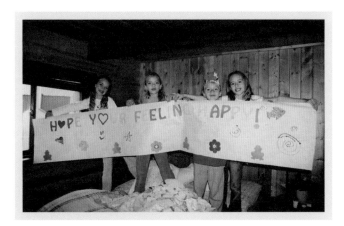

I HAVE ONLY BEEN TO THE EMERGENCY ROOM ONCE IN MY LIFE - THIS
PICTURE WAS TAKEN AFTER THAT TRIP. I HAD BEEN PLAYING AROUND
IN THE BATHROOM AND SLIPPED. I JUST HAPPENED TO HIT MY CHIN
ON A COMB WITH THE TEETH STICKING STRAIGHT UP AND IT SPLIT
MY CHIN WIDE OPEN. MY MOM PUT ME IN THE CAR AND DROVE ME 25
MINUTES TO THE NEAREST HOSPITAL. I ENDED UP NEEDING SEVEN OR
EIGHT STITCHES. WHEN WE GOT HOME WE FOUND THAT MY SISTERS HAD
MADE A SIGN FOR ME THAT SAID 'HOPE YOUR FEELING HAPPY!' THEY
WERE ALL WAITING TO TAKE CARE OF ME. MY SISTERS HAVE ALWAYS
LOOKED OUT FOR ME.

Growing up, my parents always had us help around the house and do chores. We had a 'Get to Do' list that had to be done in the summers and after school before we could hang out with friends or mess around. My mom called them 'get to do's because she said it sounded more positive than 'have to do's. One summer my parents had what they called 'zones'. We each had a specific section of the house that we were in charge of keeping clean. My dad would walk around saying things like 'own your zone'. After meals we had 'Kitchen Krews' – we each had a job to do, like dinner prep, dishes, sweeping the floor, cleaning the table or cleaning the island. If we had a large project or goals that we set together, we'd have a 3 x 5 card meeting. We'd write down all the items we needed to get done on 3 x 5 cards and then we'd hang them on the wall. We'd pick something off the wall to do and get it done.

My parents taught me how to work as a team. Once we had to pack, move apartments, and be on the road for my uncle's wedding in Utah all on the same day, and we did it. When we work hard together we can do amazing things.

My dad, Dallon, was born in Whittier, California, and came from a family of eight kids. He is a musician and grew up playing a lot of music. He's really fun and likes to joke around, and he loves sarcasm. I think he always tries to find a good balance between being a dad and a friend. I wouldn't say he's strict, but it just depends on the circumstances. Like, if I do something wrong or bad, he doesn't care so much about what exactly happened, but he cares a lot more about my intention behind it, or if I really learned something or not. He doesn't mind people making mistakes, he has a lot of patience with that, but he has little time for stupid people. He's very loving and he's definitely more of a 'spirit of the law' guy than a 'letter of the law' guy.

I HAVE GREAT PARENTS. THEY HAVE A REALLY STRONG RELATIONSHIP AND HAVE BEEN MARRIED FOR 26 YEARS SO FAR

My mom, Sheridan, was born in Provo, Utah. She also had a big family. She is the eldest of six kids. My mom is very caring and will do anything for the people she loves, and she always fights for what she believes in. She's not really strict, but she expects me to do and be my best with whatever I'm doing. My mom has high standards and expects great things from all of us. She loves to be very involved with my sisters and me, but knows when it's best to back off. I love her so much. I think we have a very close relationship. She's also super creative and artistic, and she never lets me forget that she was my first and original stylist! She's always on the lookout for cool vintage things for me to wear. I usually like to double-check with her what I'm wearing to events.

Starlie is the eldest of the kids. She's a great listener but she's not judgmental. I feel like I could tell her anything. She's very caring and always makes sure I'm doing ok, and we share a lot of inside jokes. Starlie is smart in general, but is especially street smart, with a great sense of what's real and what's not and people's intentions and vibes. She loves great food and also has a big passion for performing music. She always wants to be a part of the planning process of things we do. She taught me to always be myself.

Daisy, coming in at number two, is so fun to hang out with. She's very intelligent and loves to do the right thing. She's a real long-term thinker and planner, with the big picture always in mind. Daisy is my go-to person for life advice or when I get myself in a situation and need a little extra help. She always wants to be on the inside of a joke, and loves vintage things. Her first car is the raddest light pink 1957 Chevy Bel Air. Daisy is always up for some kind of fun activity.

Pyper is my youngest sister and always in the moment. She is totally energetic, witty, funny, and crazy. Pyper is super fun to hang out with and really spontaneous – you don't always know what she's gonna say or do next. She's so talented, and can easily make friends with anyone. She's very inspiring and taught me not to care what people say or think about me.

SHE TAUGHT ME TO ALWAYS BE MYSELF

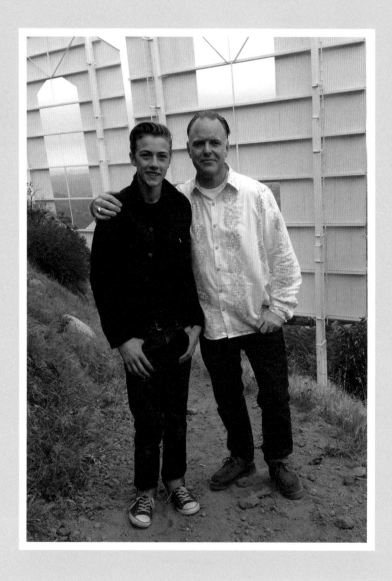

DALLON I thought I was specialist. With three girls in a row I wasn't feeling overly confident that there was a boy in the cards for us. I can also say, without hesitation, that the idea of all girls didn't bother me at all. But when Lucky was born, it was a thrill, to say the least, and I couldn't wait for all the cool boy stuff we would do together in the future.

Lucky has always been a great kid, and it has been a privilege to watch him grow into such a great young man. Until he turned 18, Sheridan and I took turns shadowing him around the world, and it's been nothing short of amazing. He was thrown into this fast-paced, competitive, adult world at a very young age, and has handled it like a true champion. Aside from the painful, if not impossible, task of getting him out of bed in the morning when he has to be somewhere on time, I've loved every minute of spending time with him.

Lucky, I'm truly the lucky one to be your dad, and I love you so much. Let's make the next 18 years even better. I know you'll never be able to pin me in wrestling, or beat me in a strength contest, and I know that when you punch me in the arm I sometimes mistake it for a fly landing there, but that's ok, we will always find fun stuff to do together. Love, Dad.

SHERIDAN I had my hands full with two toddlers and a baby, so having another child was not really top of my agenda but I kept getting the overwhelming feeling that someone was missing from the family. It happened several times until I couldn't ignore it any more. About 10 months later a beautiful baby boy with curls and big blue eyes was born. Having a boy was a totally different world to having girls. I fell in love instantly – we all did.

Lucky Blue was a busy baby and boy. He never stopped moving and going. At a very young age it became important to him to make sure I was listening. He would take his little hands and put them on either side of my face to make sure I was focused on him and what he had to say. It is still important to him that you be totally focused and listening.

He has always been a happy-go-lucky kind of guy with lots of energy, who is motivated but fun and doing. Being in the fashion industry has been amazing for him, with all the moving and shaking and traveling about. It seems to suit his personality.

Lucky has always been naturally polite. Even as a little boy he would say please and thank you to the people around him. He is very loving and kind and wants everyone to be ok. He sticks up for the underdog and doesn't seem to care what people think. He has always been unique and has a heart of gold. No matter how far he has gone and how many people know about him, he continues to 'stay golden'.

He has never been shy about showing his affection for me, his dad or his sisters. He makes you feel loved and cared for. He has given me multiple hugs a day almost every day of his life. I am truly amazed by how he handles things and the incredible man he is becoming. I am blessed to be able to share this journey with him and I look forward to many more adventures, hard work, fun, milestones, success and just living life – watching him and supporting him to do all that he wants and dreams of. Love you, Boy Wonder, you are absolutely Deluxe!

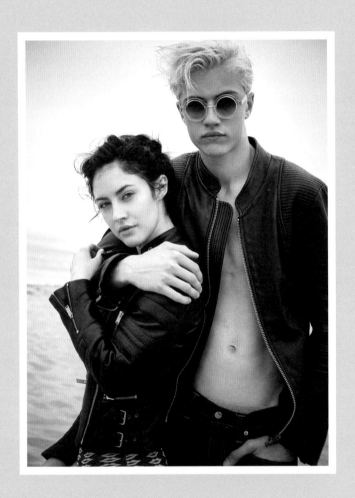

STARLIE Growing up, Lucky has always been one of the most important people in the world to me. If I'm ever feeling down he is always the first to give me a huge hug or grab my hand and ask if I'm ok. He gives the best pep talks and always builds my confidence, making me feel like I can do anything I desire. He has always been so much fun to be around. Whether we are listening to rap in the car, eating way too many sweets or sneaking off to scheme business plans, I always love the time I spend with him.

Lucky, I'm incredibly proud to be your sister. You are cool, accepting of everyone, stylish, smart, and so much more. Actually, now that I think of it, you probably got all that from me, but who can really say...? I love you, dude! I can't wait to see all you accomplish in your life.

DAISY Lucky is one of the most magnetic people I have ever known, and the truth is that he has been that way as long as I can remember. He has that perfect combination of not caring what anyone thinks of him, but still caring so much about how he makes everyone feel. He is so thoughtful and selfless, but completely free from the weight of the world's opinions. Being around him makes you feel free to be that way, too. To be light and happy and authentically you.

The best part about getting to grow up with Lucky and watch him become the person he is, is knowing that he hasn't changed. No matter what praise he has gotten, no matter what magazine cover, or campaign he has booked, he still comes home the same humble and effortlessly cool kid he has always been. I couldn't be more proud, and I can't wait to see him become the man he is meant to be.

PYPER Lucky has been one of my best buddies since day one. I always wished we were twins and half the time we tell people we are. Since moving to LA with the family, it has been crazy to see Lucky sky rocket. Besides him growing two feet in one month, watching his career take off and seeing how many people all over the world know him has been really inspiring and amazing because he hasn't dramatically changed and really doesn't let his major success get to him.

I love working with Lucky because we don't take things too seriously. On the set of a photoshoot we're usually laughing at each other and making inside jokes. He brings good energy and light to any room he walks into. He's the best brother in the world and I can't wait to see what he does with his life in the years to come – and I love that I get to be right beside him during it. Love you, baby bro.

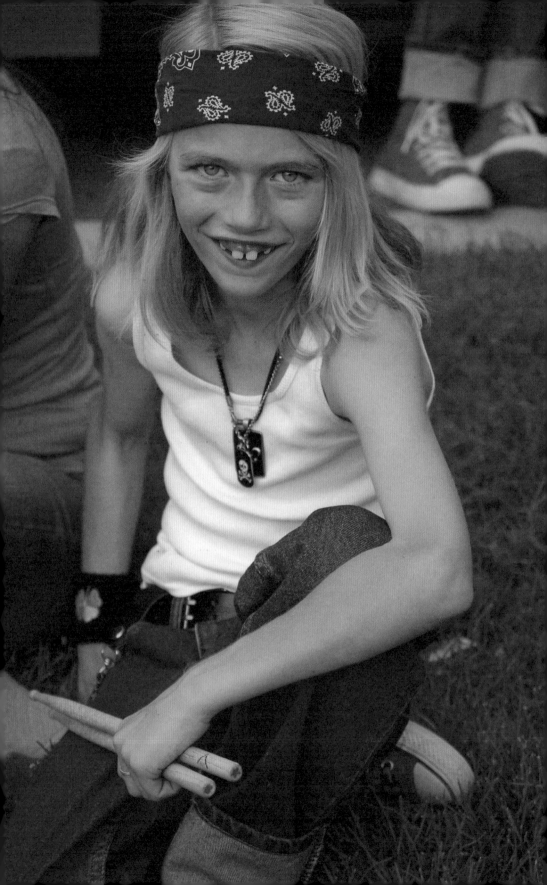

ROCK AND ROLL CHRISTMAS

Christmas 2004 was a big one and, along with presents, Santa brought a whole new beginning. I was only seven years old, so I was in full Santa mode and believed every bit of it. And that year, I'm pretty sure I was in charge of putting out cookies and milk for Santa, and carrots for the reindeer on Christmas Eve, which we did every year for as long as I can remember. Then we'd have our traditional Christmas Chinese food and golden presents!

At some point in the past, my mom decided she'd had enough of making the traditional 'fancy Christmas dinner' on Christmas Eve, and replaced it with Chinese takeout on fancy Christmas paper plates. I think she was inspired by that movie, *A Christmas Story* – I love that movie! Anyway, it's become a family tradition and I really enjoy it. Then, from what I understand, when my dad was a kid, he and his siblings talked his mom into allowing them to open just one present on Christmas Eve. Somehow, that turned into a tradition of wrapping that one present in gold wrapping paper. So, my mom and dad started doing it with our

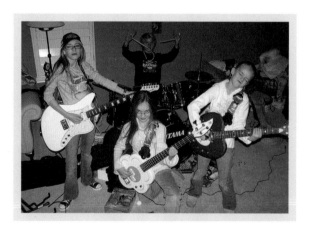

family. The golden present is not necessarily the best present, but it's definitely one of the good ones. So we have our Chinese food and we each open our golden present, and then all the kids go to sleep in the same room, no matter what. And that's our Christmas Eve.

I would always go crazy on Christmas morning. First, you had to wait for my parents to get out of bed. Then my mom would make everyone brush their teeth. I would usually fake that. Then, you had to wait till my mom was ready. Hours. And you couldn't go see the presents until my dad was ready with the camera. And you had to suffer with him saying in a loud voice things like, 'Ohhhh man,

ALONG WITH PRESENTS, SANTA
BROUGHT A WHOLE NEW BEGINNING

you can't believe what's down here!' Or, 'This is amazing! I don't know if you guys can even handle this today! We might have to wait until tomorrow.' Things like that to drive us crazy.

But this year was different. When the floodgates were finally opened, we ran over to the presents and saw all kinds of musical instruments. I got a new blue 5-piece Tama drum set. And I wasted no time in running over to it. I remember wondering if it was really mine. Starlie got a white sparkle guitar. Daisy got the coolest 'Daisy' bass. And Pyper got a red heart guitar. There were amps, tuners, picks, cords ... everything! It was amazing. A total rock and roll Christmas! We were all very excited. My dad told us that he would teach us, and if we wanted to, we could start a band. I think everyone was pretty stoked about the idea.

THE
BEAR
VAN
AND THE
BEACH

I t all started with Daisy. When we were little kids, Daisy was the one that really talked about becoming a model. My mom was a model back in the day, so we heard stories about her once in a while. I guess that started Daisy's interest in modeling. Around the time I was 10 years old, Daisy was thrilled when she met a scout in Utah. Sometime later, management from NEXT Models in Los Angeles came to Utah on a scouting trip to meet potential models. It was absolutely the last thing on my mind or my radar, but Daisy made plans with my mom to go meet with them in Salt Lake City. My mom dragged me along too – she didn't take me with her so I could meet them as well, I was just along for the ride. After all, I was only 10!

We went to some kind of big room with a huge group of girls waiting in line. When it was Daisy's turn to go into

I WAS JUST ALONG FOR THE RIDE.
AFTER ALL, I WAS ONLY 10!

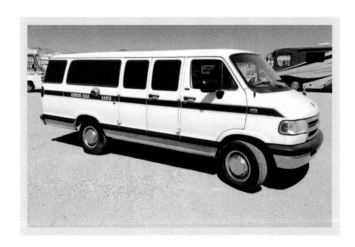

another room, my mom and I went with her. That's where I met Alexis Borges for the first time. He was the director of NEXT, Los Angeles, and he seemed pretty nice. He started talking to Daisy and took a bunch of pictures of her. I wasn't really paying attention to what was going on. I just wanted to know when we could get out of there so I could get some hot wings. My favorite. My mom and Alexis talked for a little bit, and Alexis wanted to know if Daisy could come out to Los Angeles sometime in the near future to do some test shoots and meet some people out there. At one point, he looked at me and said, 'Who's that?' My mom introduced me, and he said that he wanted to keep an eye on me and see me in a few years.

Within a month or so, Daisy was signed with NEXT. She wasn't going to make a trip out to California yet, but at least she was signed and things were moving forward. It actually took about two years before the whole family went to California, and nothing really happened with Daisy's modeling during that time. We were all pretty much just living a regular life in Utah. Everyone was simply going to school and doing normal things. We were learning how to play our instruments, but nothing too heavy.

Finally, in the summer of 2011, we made it to California for a beach vacation. Part of the plan was to go by and visit the NEXT office in LA. We drove there in our huge, long, slightly embarrassing, but maybe cool – wait, actually not cool at all – 15-passenger 1994 Dodge Ram Van with an enormous Running Bear Ranch logo plastered on the side. We called it the Bear Van. For years, it had stayed at the Montana property for anyone to use when they went to the lake on vacation. My family took it over around 2007. That van had more memories and history than you can imagine

– not just for our family, but for all our extended family and friends. Not only could it fit everyone comfortably, it could hold a ton of luggage, music gear, you name it. It was perfect for road trips. Whenever people asked what Running Bear Ranch was, my dad usually told them that we ran a nudist colony on the side! Anyway, the Bear Van is a classic.

When we got to California, we stayed with some family members in Orange County. All I wanted to do was go to the beach at T-Street. It was August, and the weather was perfect. But, of course, the day after we got there, we had a meeting at the NEXT office in LA. We were staying in San Clemente, so the drive was about an hour and a half with no traffic.

Even though I wasn't that excited about going to the NEXT office, I still had a decent attitude about it. The main reason we were meeting with them was for Daisy, and I was excited for her. We all were. Because we were on vacation, my mom told them the whole family was coming in and they would be able to meet Pyper, too. Pyper was growing and almost as tall as Daisy, but she was still only 13 years old. I was 12 with buckteeth and braces – I wasn't on their radar at all.

Before long, we were all sitting in their conference room talking about modeling and what the Smiths were up to. It was really a get-to-know-you kind of meeting. My mom said they seemed a little overwhelmed by us all. The meeting wasn't too long, but it was very positive. We told them we were going to be in town for about a week just hanging out at the beach.

Although nothing significant was really talked about, both my parents could tell that the wheels at NEXT were

definitely turning. On our way back to the beach, about 20 minutes after we left the office, we got a call from Alexis. He said something like, 'Hey, we've been talking here after you left. Is it possible for you to come up to the office again tomorrow? I want to get our whole staff together this time and have another meeting with your family.'

That sounded really cool, but what it meant to me was another day away from the beach. What could they possibly want to talk about that they couldn't say when we were there? I had no clue. Whatever. At least my family was very intrigued.

WE WERE GOING TO BE IN TOWN FOR ABOUT
A WEEK JUST HANGING OUT AT THE BEACH

The NEXT office is amazing. It's in Beverly Hills on Wilshire Boulevard. They have the penthouse suite on the top floor with great views of Beverly Hills and Hollywood. It's also kind of like you are on the roof, because you can walk out on to what you think is a balcony, but it's really a rooftop that wraps all around the offices. Sometimes they do parties there with live music. It's pretty rad.

This time, the meeting at NEXT seemed different. There were a lot more people from their side that showed up. It was like they'd had a chance to process it and think about things more. They had all kinds of questions. Everything seemed to be more serious, but still fun. Alexis asked each of us what we wanted to do, what goals we had, what our interests and passions were. He asked if any of us had any interest in acting, and he asked us about our band, The

Atomics. We talked about everything. When Alexis said things like, 'And Lucky, I can see you doing this, and I can see you doing that,' I was just wondering how all this was going to screw up my beach vacation.

Alexis asked if our family was interested in moving to LA and my parents were like, 'Uhhhh no, not really. Hmmmm, I don't think so.' We were pretty excited about the idea, but I saw no glimmer of hope from my parents.

And then I met the person who would change everything for me. The person who would play a major part in my new career, and in the years to come … Mimi Yapor.

When I first met Mimi she seemed kind of quiet and sort of intense. She didn't say very much and was very

ALL OF A SUDDEN, CONTRACTS HIT THE BIG WHITE CONFERENCE TABLE

focused. She asked who I was and I introduced myself. She commented on my retro, slicked-out hair, so maybe she thought I was pretty cool. And then it was all about getting digitals and seeing how tall I was. I had no idea that she would end up becoming 'Mimi The Super Agent' to me.

Everything got real exciting when Alexis said they wanted to sign everyone! All of a sudden, contracts hit the big white conference table. I was thinking, 'Wait, what? I'm gonna be a model? Don't they know I'm 12 and have braces? How is that going to work?' Before I had much time to process what was going on, we all separated to different parts of the office to take digital pictures and measurements.

On the drive back from NEXT, it was kind of quiet in the Bear Van. We all had lots to think about. I'm sure for my parents, the thought of moving to California started to take on some weight. Maybe not too much weight, but at least a real seed was planted. I knew that my beach days were being whittled down but, at the same time, great things were happening. We ended up driving straight to the beach that day with our minds filled with new thoughts about the future.

GREAT THINGS WERE HAPPENING

Later that evening, someone from NEXT called and said, 'Hey, Lucky and the girls have a big shoot tomorrow with Hedi Slimane in Hollywood!' Again, I was like, *Wait, what?* I had no idea who Hedi Slimane was. I don't think any of us knew who he was, except maybe my mom. I'm not sure exactly how it all came about so quickly, but Mimi said it was a very big deal and a killer opportunity. She said it was a shoot for *Vogue Hommes Japan* magazine, which sounded amazing. It was definitely one of those opportunities you just have to grab with both hands, but none of us could really believe what was happening.

This is one of the very first test shoots I did after I was signed to NEXT. It was done with a now family friend and photographer Ryan Astamendi. I didn't really know what to do or what it would be like but he took some amazing images that day. It's a classic and one of my mom's all-time favorites. We've had some fun photoshoots with him. He really helped us out and saved our bacon when we had little money and were traveling back and forth from Utah to California. He has always been so kind and let us stay at his house before we moved. He is the one who taught us all about ice cream cereal.

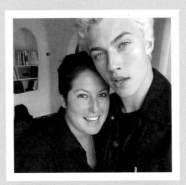

Mimi is the main driving force behind all my success. I know there are many great agents out there, but I was lucky to have Mimi. We got along really well and I was glad it wasn't just about business all the time. I knew that she cared about me. Mimi also tried to make things fun and cool. We would spend countless hours traveling, strategizing, eating hot wings, shooting hoops, and booking amazing jobs together.

Mimi is very smart, strategic, creative, and a great negotiator. She always had a clear vision and plan for developing my career. She always pushed to get the best for me and would take the time to explain why I should or shouldn't do something. It really helped me to keep the big picture in mind. She wasn't afraid to tell me when I screwed up, but she was always encouraging. I think she's the best modeling/talent agent on the planet. Thanks for everything Mimi! I love you.

OPPOSITE: DIGITALS ARE A BIG PART OF EVERY MODEL'S LIFE, AND THIS ONE IS HISTORIC. THIS WAS SHOT BY MIMI AT THE NEXT OFFICE ON THE FIRST DAY I MET HER. I REMEMBER THINKING, 'WHAT ARE DIGITALS AND WHAT AM I SUPPOSED TO DO?' IT'S CRAZY TO THINK HOW FOREIGN BEING IN FRONT OF THE CAMERA FELT THEN BECAUSE I FEEL RIGHT AT HOME IN FRONT OF IT NOW.

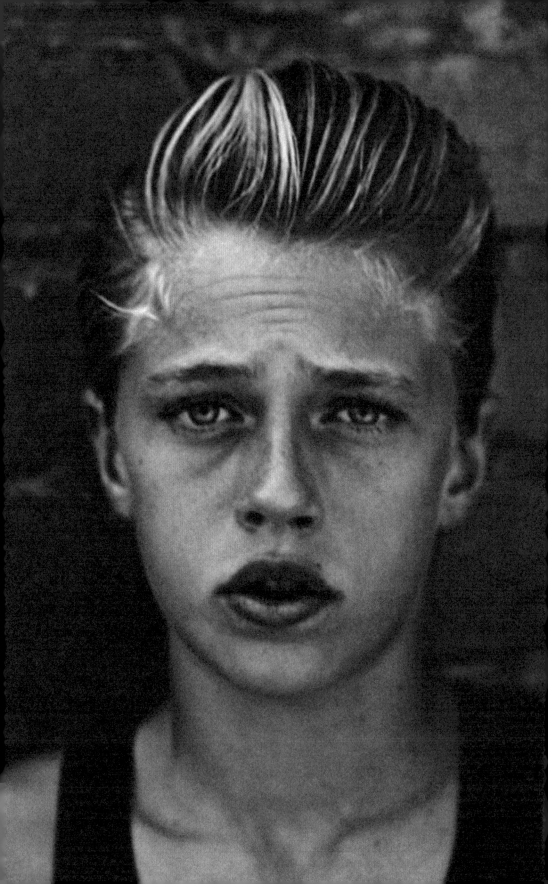

FIRST
EDITORIAL
SHOOT

There we were again, heading up to Hollywood in the Bear Van. I remember it was a pretty hot day and the traffic sucked – the air conditioning in the van barely worked. My parents weren't too happy with me because I stayed up until, like, 3am playing video games, and pretty much had bags under my eyes. The night before we'd done some Google research on Hedi Slimane and were excited to meet him. The girls were wondering if they might be able to get in on the shoot also but, honestly, we had no idea what to expect. We also found out that morning that the shoot was at a music rehearsal studio, which kind of threw a whole new set of questions in our minds. Were we going to play any music? Were The Atomics involved in any way? Did we bring the right kind of clothing?

We found the studio and started unloading. We brought our instruments just in case he wanted us to play something. The studio room was big enough to fit everyone. It had a

MY PARENTS WEREN'T TOO HAPPY WITH ME BECAUSE I STAYED UP UNTIL, LIKE, 3AM

small stage and a couple sofas. As usual, there was a drum set and a couple microphones ready to use. We went ahead and set up to play, even though we knew we might not actually get a chance to play.

Hedi was really nice. He seemed excited to be there and had some fun plans for the shoot. Someone showed up with a birthday cake with metallic gold frosting. Hedi thought it would be cool if we started playing, so we

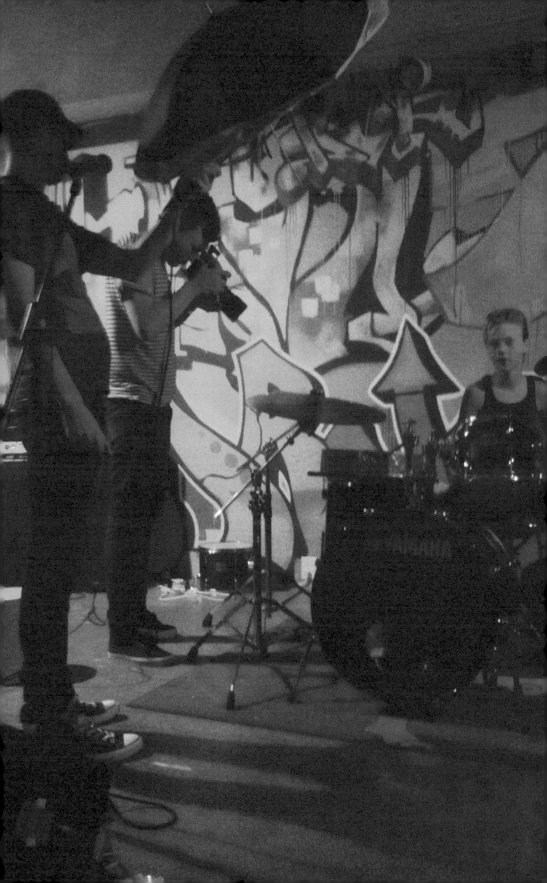

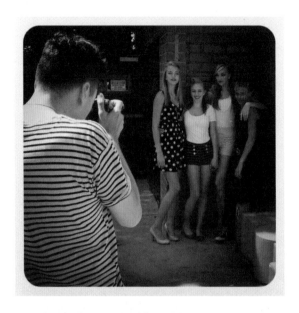

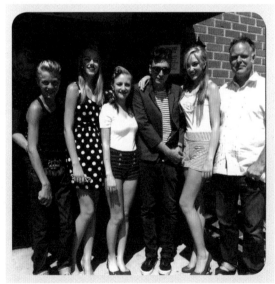

plugged in and tuned up. He had one guy to help with lighting, and he started shooting as we played. It was going really great. Hedi was so quiet, but moved around the room getting different angles. You could tell that he was very artistic and was focused on getting exactly what he wanted. At some point he grabbed the cake and set it next to the drums. We lit some candles and I blew them out like it was a happy birthday to me. Next, he said to play on the cake like it was a drum. I started out pretty slow and careful, but he wanted me to hit it harder like I was really playing a solo on a drum. As you would imagine, the cake started not to look like a cake any more, and he was snapping pictures about as fast as I was playing. When he was done, we were done. The whole shoot was over pretty quickly. Hedi was very kind and easy to work with. He gave everyone hugs and we got a nice picture with him. What a great experience shooting with such a legend!

I couldn't wait for the magazine to come out. Because it was Japanese, we had to order it from a Japanese bookstore called Kinokuniya in LA, and when it hit the stands, we bought a few copies. Sometimes, the magazines I'm in are so hard to find, especially the foreign ones. It was really weird seeing myself in a Japanese magazine, but it was very cool.

HEDI WAS VERY KIND AND EASY TO WORK WITH. WHAT A GREAT EXPERIENCE SHOOTING WITH SUCH A LEGEND!

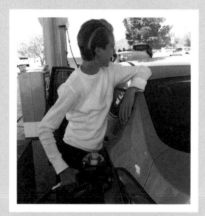

John John Denim was my very first paid modeling job when I was 12 years old. My mom and I drove down to LA together. This was a totally new experience for me. I remember feeling so glad my mom was there. It was a two-day shoot in a couple great locations. The first day was way out in the desert in Lancaster at the coolest place called Club Ed, which is a movie set. And the next day was in Venice Beach. It was pretty intimidating because I was so young and I was surrounded by older models. Plus, I had absolutely no idea what I was doing. But everything went smoothly and they said they really liked me. Apart from the time when the catering guy was sweating into the BBQ and it made me lose my appetite, it was totally rad. So, yeah, I got out of school for a few days, got to go on a fun road trip with just my mom, got to hang out at interesting places, spent time at the beach, ate good food, and then got paid for it. Uhhhh, I think I can do this.

OPPOSITE: THIS IS ME PUMPING MY MOM'S GAS ON THE WAY HOME FROM THE JOHN JOHN DENIM SHOOT. WHETHER IT'S LADIES FIRST OR OPENING DOORS FOR PEOPLE, MOM HAS ALWAYS TAUGHT ME TO HAVE MANNERS AND BE A GENTLEMAN.

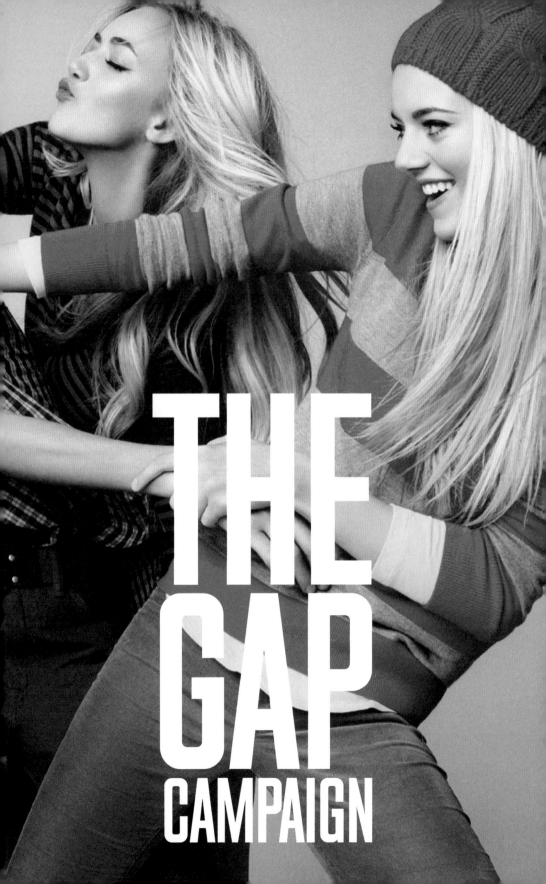

Within two years, after signing with NEXT, my mom, always traveling with at least one of us, had made about 15 different trips to LA for various jobs. Around the summer of 2012, we got a call from NEXT. They were excited to tell us that Gap were really interested in all of us for a big Christmas campaign. We were so stoked. We couldn't believe it. The money was great, but the best part was that it was a job for all of us. The campaign was about 'Love in Every Shade' and about people who have special relationships. It was a huge opportunity if we got it. The money situation at the time was really stressful for my parents, so getting a job like this would be so good for us.

A few days later we heard that we were officially put on option. So it was looking real good. It's hard to wait patiently sometimes. You think you're gonna get the job, but then you don't know. Sometimes you think for sure

GAP WERE REALLY INTERESTED IN ALL OF US FOR A BIG CHRISTMAS CAMPAIGN. WE WERE SO STOKED

it's yours, then the call never comes. Sometimes you believe there's no way you will get it, then you do. Honestly, it's a lot better for me just to forget about it and pretend that the potential job doesn't exist. That way I don't worry about it at all, and it doesn't affect me when something doesn't come through. Anyway, that works for me.

Finally, a solid hold for Gap came through, and then, a couple days later, it was on. We confirmed it! And, of course, we had to be in Hollywood in a day and a half.

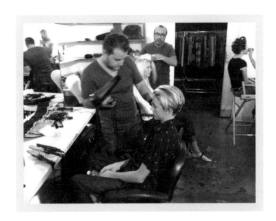

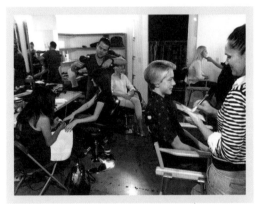

We were all so excited about going. And, at the same time, we could hardly believe it. My dad and I got the Bear Van all ready to go, and everyone packed as fast as we could. We got to miss the first few days of the new school year, which was starting that week. Bonus!

My grandparents, Bema and Gramps, lived in Hurricane, Utah. We'd usually stop by to visit them on the way to California. They lived right on the way. This time, though, the van was filled with both excitement and anxiety. Money problems were really stressing my parents out. It's crazy to have such an amazing opportunity, but not be sure if we could afford to make the trip. We had to stop and get some help with gas money from Bema and Gramps. They were always so kind, loving and helpful. Every trip, they made us promise to tell them every single detail about our adventures. Bema and Gramps both grew up in Los Angeles. Bema was an LA beauty queen and fashion model, and Gramps was a staff photographer for the *LA Times*. They couldn't get enough of all the stories we had for them. Their support for us was amazing and priceless.

On the drive to Hollywood, about every hour or so, we would get more details through from Jennifer Powell, from NEXT, who was our main contact for the job. She was great to work with, and was so nice. As we got closer to California, Jennifer called us with some amazing news – she was able to negotiate more involvement from us in the campaign, which doubled the rate! Everyone freaked out in the van. We could hardly believe it. Another thing that was kind of funny was that we knew we were heading to Hollywood, but we had no idea where we were staying, or if a hotel was included in our deal. It wasn't until we were about 30 minutes away that Jennifer called again and said

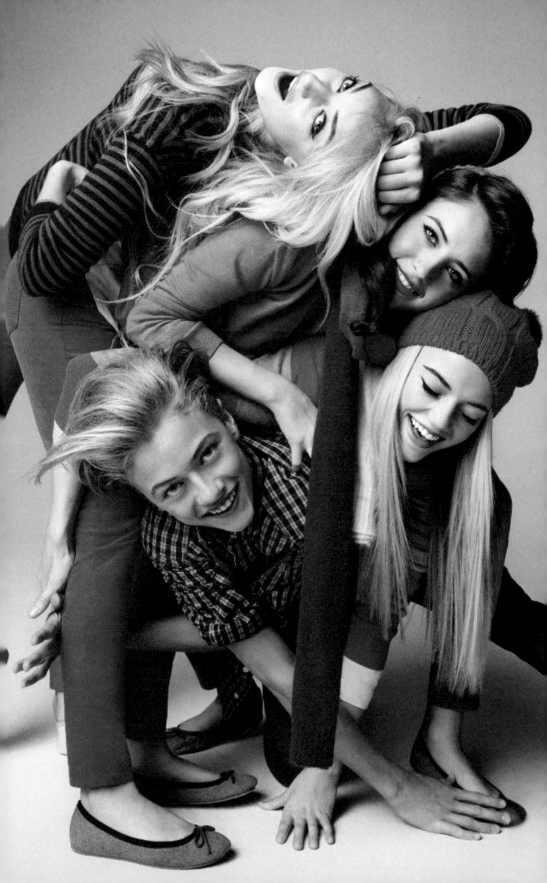

Gap had booked us into the Mondrian Hotel on the Sunset Strip. I didn't know anything about the Mondrian or the Sunset Strip, but it sounded very, very cool to me.

Pulling up to the front door of the fancy Mondrian Hotel in the Bear Van was a little bitter sweet. My dad said it felt like we were The Beverly Hillbillies, and couldn't wait to find a parking spot somewhere 'not too close' to the hotel. But the rooms were amazing and the Sunset Strip was alive and kicking. We were knocking on Hollywood's door, and the feeling in the air was unforgettable.

We had an early morning call time at Milk Studios, not too far from the hotel. Walking into the studio, you could tell this was a big production. It was a little overwhelming. One of the rooms was filled with a shocking amount of Gap clothing. There were lots of staff and sewing machines, and we got started right away with fittings, styling, and hair and makeup. It was very serious stuff, and these guys were absolutely on it. During that time, someone came in with a 'business as usual' attitude and handed each of us kids an envelope with a bunch of cash in it! It was *per diem* for food. We actually ended up using some of the money to buy school supplies at a store in Hollywood.

The shoot was amazing and very busy. We did it all... still shots, video, and interviews over two days. The people in charge seemed to really like how we were doing. For me, it was so much fun doing it with my sisters. We had a blast. I'm sure everyone was a little nervous, I know I was, but it made it a lot easier to be working with them. That Christmas, the campaign came out everywhere. We had friends from all over tell us they saw it and took pictures. It was an awesome experience and a ton of fun. It really felt like great things were starting to happen, for all of us.

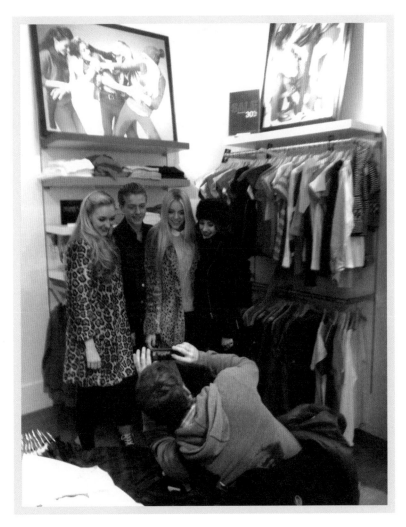

THIS IS A BEHIND-THE-SCENES SHOT OF WHEN WE WERE INTERVIEWED
AND PHOTOGRAPHED BY *CITY WEEKLY* IN SALT LAKE CITY AFTER OUR
GAP CAMPAIGN CAME OUT.

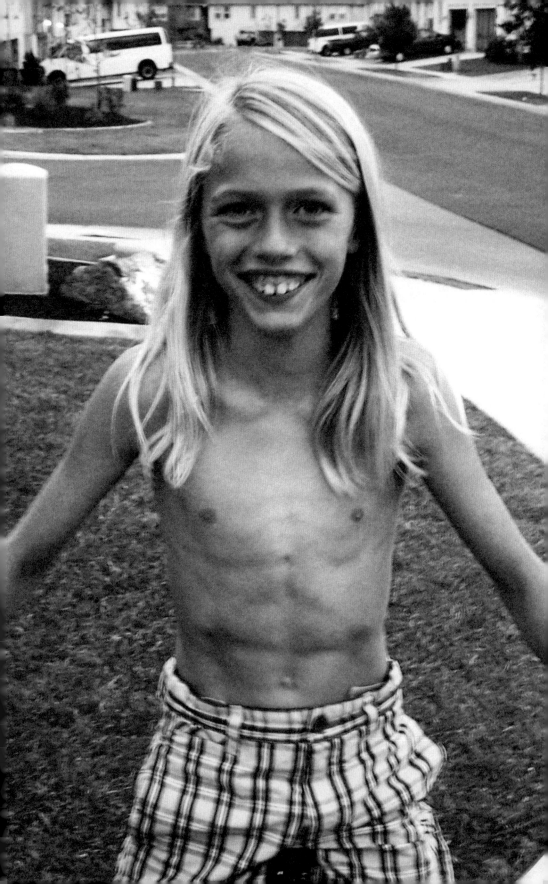

HATERS GONNA HATE

've always been slightly different than the average kid I grew up around. But I think in a good way. My parents don't really conform – they do things a little differently and like to think out of the box – and I guess it's rubbed off on me and my sisters. When I was nine years old my hair was down to my chest. Later, I looked like a kid from the 1950s and wore very retro-style suits to church. Oh yeah, not to mention, I was heading straight for the fashion and modeling world at the age of 12.

I learned early on that when you are different, you have to deal with people who don't like 'different'. When we moved to Spanish Fork, I was bullied just about every day by a couple of kids because of my long hair – one of them was in the 3rd grade like myself, the other was in the 6th grade. We rode on the same bus to school and they

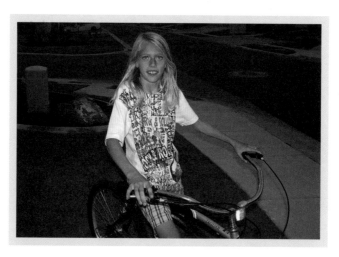

THIS IS A TYPICAL 'LUCKY IN THE SUMMER' PICTURE – NO SHOES, RUNNING AROUND LIKE A WILD ONE WITH MY LONG HAIR.
I GOT THIS BIKE FOR MY BIRTHDAY – I WAS THE FIRST ONE ON THE BLOCK WITH A BEACH CRUISER.

would call me names and say all kinds of mean things to me. I kind of put up with it and didn't make a big deal about it for a couple months. I thought it might just go away. But it kept getting worse. So I told my parents about it and they were pretty concerned. My dad told me to stick up for myself and told me that I didn't need to take it any more but they kept coming at me. I knew they were just a couple idiot kids, but this was really starting to get me down.

I LEARNED EARLY ON THAT WHEN YOU ARE DIFFERENT, YOU HAVE TO DEAL WITH PEOPLE WHO DON'T LIKE 'DIFFERENT'

Finally, my dad told me that I basically had two choices – keep putting up with it, and it will probably get worse, or stand my ground and put an end to it. So that's what I did. And guess what? Somehow, all the bullying stopped. And never happened again with those kids.

Later, as I started to get busy with modeling and began to gain a lot of followers on Instagram, the haters started to appear. I usually get along with everyone but, all of a sudden, here were guys I'd never met dishing out the hate. I know a lot of bullying comes down to jealousy and ignorance and all that but, still, it's just so dumb and pointless. Thanks to the advice of people I love and trust, I have no problem at all ignoring it and just shaking it off. And I've become friends with the fact that there will always be idiots out to get you. That's just part of life.

When things and opportunities started to heat up for our family, and not long before we moved to California, we had a bunch of times when people threw eggs at our

house and cars. We also experienced a decent amount of cyber bullying – people hacking into our social media and pretending to be one of us. But there have also been a few times when my sisters have been threatened, and that takes it to a whole new level.

When it comes to defending my sisters or a girl, I will never be afraid to fight. One time when I was in junior high school, Daisy and I were home alone one night when I heard someone knock at the door. I ran downstairs to get it and when I opened the door there were a couple guys standing there looking a little sketchy. I thought I might have seen them before, but wasn't sure. I thought they were seniors from the local high school but I didn't know

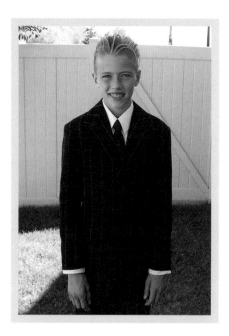

THIS IS THE FIRST SUIT THAT I PICKED OUT ON MY OWN. ALL THE OLDER BOYS AT CHURCH WANTED TO KNOW WHERE I GOT IT. NO ONE HAD A SUIT LIKE MINE.

them. It was strange because when I opened the door, they kind of took a few steps back, like they were expecting someone else. There were a couple more guys sitting in their car next to the sidewalk in front of our house looking over at us. It felt like something was about to go wrong.

Before I could say anything, they started talking crap about my family. Saying things like 'The Smiths suck! You guys think you're so cool' and a few other little threats aimed at me. I wasn't sure if I should get into it with them, so I just shut the door. It was probably a good thing that my dad wasn't home. After dealing with a few egg incidents, things would have gotten ugly quick. Just a couple minutes later, there was another loud knock. I opened the door and they started again. This time, there were three of them and only one left in the car. They started saying a lot of bad things about my sisters. That's where I drew the line. I stepped outside and walked toward them, probably saying the classic 'Whadjujassay!' phrase.

I went up to the biggest one and pushed him. We had a little fight but when it looked like things were gonna get heavier, they all took off, running to the car and driving off.

Another time, I was getting the mail when some idiot with a hoodie came up to me telling me all the bad things he was going to do to Pyper. I didn't waste any time setting him straight. I'm sure that haters are always gonna be around. I just don't understand it. Especially when you don't know someone and you have done nothing to them.

WHEN IT COMES TO DEFENDING MY SISTERS OR A GIRL, I WILL NEVER BE AFRAID TO FIGHT

This is the first picture that was taken of me after I got my long hair cut and donated it to Locks of Love. I saw Lee Rocker of the Stray Cats play a show because he borrowed my dad's double bass and I thought his hair was so cool. Then I met the Maxwell boys, who also had their hair cut short, pomped and greased up. Before I got it cut, my mom kept asking me if I was sure. She took me to an old school barber called Jim, who knew just what to do. Once I decide on something it's pretty hard to get the idea out of my head.

This is just me being silly. It's good not to take yourself too seriously. You have to be able to laugh at yourself. I don't really get embarrassed. If you find things to be confident about and you like yourself then it doesn't really matter what other people's opinions of you are. One of the things I do is be nice and outgoing with everyone – it helps me make friends with lots of people. I think that made a positive difference with my confidence. Also I don't let other people's opinions of me define who I am.

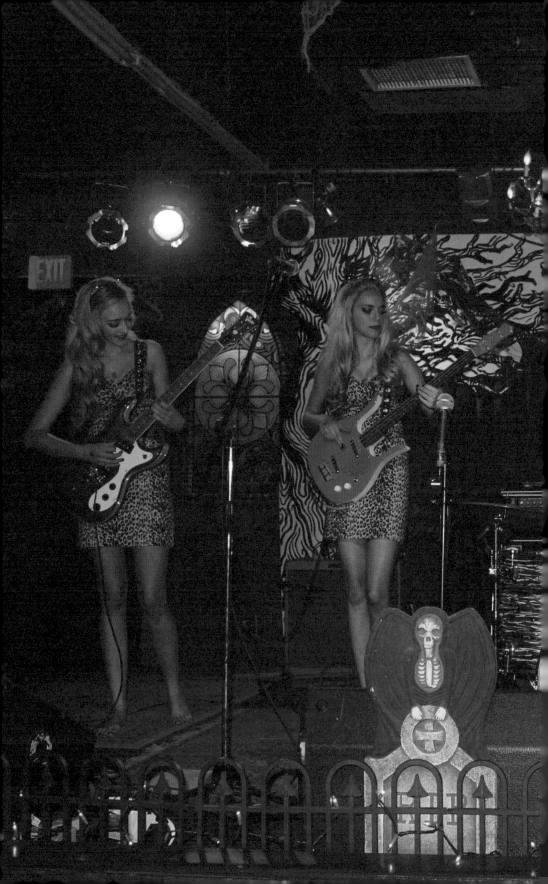

THE ATOMICS!

Ludwig

don't think there was really a date when it all started. It just kind of grew. It was always a given that if I was ever going to be in a band, it was going to be with my sisters. And I have always loved that idea. We all grew up watching my dad play music. He was always playing something somewhere. There was usually a soft acoustic guitar playing in the house – it was a sound we'd fall asleep to at bedtime. My dad can play a ton of instruments but, growing up, I always thought it was cool watching him play the drums or the double bass.

It seemed like the natural thing for me to play the drums. That was my dad's main instrument, so why not, right? Daisy started out on the bass and Pyper on guitar,

THERE WAS USUALLY A SOFT ACOUSTIC GUITAR PLAYING IN THE HOUSE – IT WAS A SOUND WE'D FALL ASLEEP TO AT BEDTIME

but one day they switched. Daisy wanted to be challenged more so she started playing guitar. And Pyper is a real natural bass player. Plus, she loves disco and all those great disco grooves on bass. Starlie was always interested in singing and playing guitar. She writes cool original songs on her guitar and has an incredible voice.

My dad taught us how to play music by ear through songs from the very beginning. He would take simple songs we thought were cool, and we'd just jump right in and learn the chords and drum beats as we learned the song. He would choose easy three-chord songs like 'Wild Thing' or Elvis records. Basic blues progressions were something that we all came to understand from the

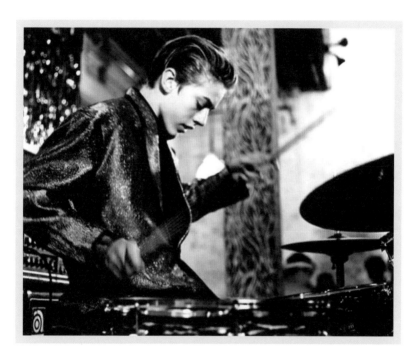

THIS IS ONE OF MY FAVORITE PICTURES OF ME DRUMMING. WE WERE
PLAYING FOR THE POLAR JUBILEE IN SALT LAKE CITY, UTAH.

beginning. Pyper learned how to walk in blues progressions. We were all weaned on roots music and classic rock in our high chairs and car seats. Chuck Berry was my favorite.

The cool thing about being taught by my dad was that, whoever was doing a lesson, my dad would be on another instrument playing a song or groove with you. If Pyper was on bass, my dad was on drums. He would usually play the bass with me on drums. He taught me all kinds of beats, grooves, and styles. We had a little game we did all the time called 'Find the Beat'. My dad would make up some kind of riff or groove on the bass and I would have to come up with a drumbeat that I thought worked best with it.

WE STARTED UP A COOL SURF MUSIC PROJECT AND THE ATOMICS WAS BORN!

When we got to the point where we could play a little bit, we started talking about making a real band. First we had to decide on what kind of music to play. Not everyone agreed on the same thing. Should we focus on classic rock or modern music? That discussion went around and around. The only genre of music that we all agreed on was surf music. Not The Beach Boys type of music – although we love us some Beach Boys – but real surf guitar music like The Ventures, Dick Dale, and Surfaris. With my dad, there was never a short supply of surf music around the house or on road trips.

So, it was settled. We started up a cool surf music project and The Atomics was born! Our very first song we learned as a band was 'Pipeline'. I think after that it was 'Walk

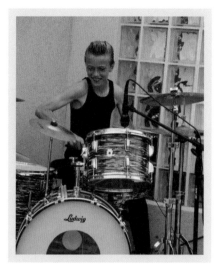

TOP LEFT: THANKSGIVING POINT, UTAH.
TOP RIGHT: THIS IS A CAR SHOW AT THE ONE MAN BAND DINER ON MAIN
STREET IN SPANISH FORK, UTAH, AND THE HOME OF MY FAVORITE HOT WINGS.

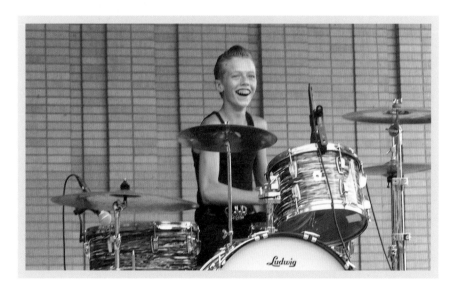

THIS IS FROM OUR VERY FIRST SHOW - I LOOK LIKE I'M HAVING FUN
AND IT WAS. I LOVE TO PLAY MUSIC WITH MY SISTERS SO MUCH.

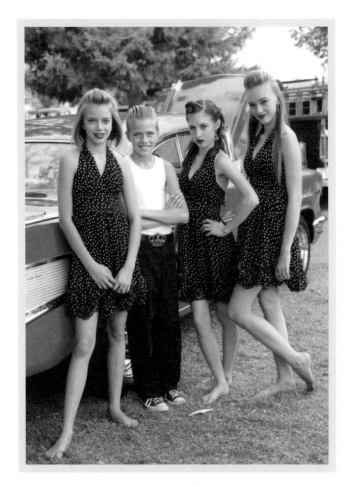

THIS WAS TAKEN AT THE VERY FIRST CAR SHOW WE EVER PLAYED FOR
FIESTA DAYS IN SPANISH FORK, UTAH, ON THE CITY LIBRARY STEPS.

Don't Run'. Our goal was to learn enough songs to play a show. We'd do individual lessons to learn our parts, then work on it as a band. Our music room in Spanish Fork was awesome. Black velvet chandeliers surrounded by light blue walls filled with hanging guitars, music memorabilia, and big, old picture frames covered with furry fabrics for noise reduction. It was perfect for practicing. Neighbors couldn't hear us, so we could pound away any time of the day or night. Everything was always set up and ready to go.

I wouldn't say we were the best at practicing, though. Our parents were always on at us about it. When encouraging words wouldn't work, they'd take it to the

BLACK VELVET CHANDELIERS SURROUNDED BY LIGHT BLUE WALLS FILLED WITH HANGING GUITARS, MUSIC MEMORABILIA, AND BIG, OLD PICTURE FRAMES COVERED WITH FURRY FABRICS

|next level – standard yelling. And when the broken record strategy failed, a well-placed threat would often do the trick. My dad always said it was like pushing a rope or herding cats. One standing rule was never to watch TV without a guitar in your hand.

Our friends knew that we played music, but I don't think anyone really 'got' the whole surf music thing. It was kind of cool because no one else, especially kids our age, was playing it. But, older people loved it. In the early days, our biggest fans were 50–70 years old. I remember playing one show and seeing an older guy crying when we played 'Pipeline'. That was pretty cool, I guess.

THIS PICTURE WAS TAKEN AT AN ATOMICS GIG AT THANKSGIVING
POINT, UTAH. IT SAYS EVERYTHING ABOUT US. THIS PICTURE IS
WORTH A THOUSAND FEELINGS. WHEN GAP WAS DECIDING IF THEY
WANTED TO USE US OR NOT, THEY SAW THIS PICTURE ON OUR
FACEBOOK PAGE AND IT CLINCHED THE DEAL.

THIS PICTURE WAS TAKEN AT ONE OF THE ATOMICS SHOWS. I CAN GET
PRETTY INTENSE AND FOCUSED AT TIMES.

Once, when we were supposed to be getting ready to play some shows, my dad had to go work in Japan for a couple months. But that didn't stop the lessons. My sisters had guitar lessons on Skype. It actually worked out pretty well. When we had about six or seven songs down, we had an opportunity to play at a car show at the city park in the summer. While my dad was in Japan, we had help from a great friend, Mitch Vice, to get ready. Mitch is a friend of my dad and a good musician. He also lived in the neighborhood – it was really nice to have him close by, and we were lucky to have him around.

Our first official gig was at the city library in Spanish Fork, for a big classic car show for Fiesta Days. Mike Nielsen was in charge of the car show, and he also owned a cool diner called Mike's One Man Band on Main Street. We played several shows in his parking lot. Mike is a really great guy and has been super supportive. The only major problem that came from Mike's One Man Band is my addiction to hot wings and buffalo sauce. I'm still suffering from that addiction today. Over the next few years we played a bunch of small shows and had a blast.

One day, my dad said, 'Hey, let's write an original surf song, record it somewhere, and then make a rad video!' We loved the idea. So we did. The song was 'Agent A.D.D.' It's a cool spy/surf song, and the first one we recorded. It was a lot of fun making the video. Of course, we had no money to spend on it, so we did what we always do … got creative, thought out of the box, and just made it happen. We talked to one of my dad's good friends, Kory Mortensen. We love Kory – one of the funniest and coolest guys ever. He made videos and was totally down to do it. The original idea was to drive up to the Bonneville Salt Flats and do something

there, but someone pointed out that it was a bit overcast and might rain, and the last thing you want is to be on the Salt Flats when it rains. So we passed on that idea. We were running out of time and had to figure something out quick. We'd heard there was an old, run-down sugar beet factory in Spanish Fork, so we took off looking for it.

It was perfect. It was one of those cool, old buildings made out of brick. Obviously my dad didn't have permission to use the property and he wasn't about to try and get it. We unloaded as fast as we could and started scouting around for good places to shoot. Just as we were setting up, a lady in a nice car drove up and said, 'What do you guys think you're doing here?! This is private property, you can't be here.' I'm not sure what my dad told her, but

WE WERE RUNNING OUT OF TIME AND HAD TO FIGURE SOMETHING OUT QUICK

about five minutes later, she drove off and my dad had permission. The video shoot was awesome. We came up with a quick story idea where I would be the one unloading and setting up the gear while my sisters primped and watched me do all the work. We began shooting. Kory was incredible and we got a great video. I'm sure you can find it on YouTube if you want to check it out.

During all this, all the practicing and gigs and ups and downs, my mom was incredible. She is our biggest supporter and number one fan. My dad has been great but without our mom with us every inch of the way, The Atomics wouldn't exist. She has been an invaluable asset,

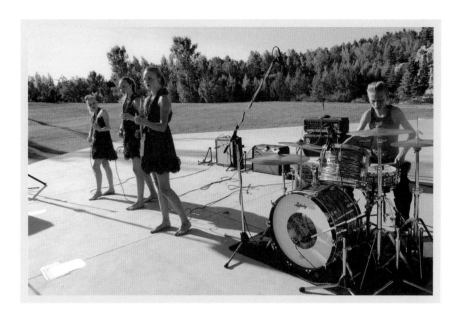

cheerleader, believer, stylist, make-it-happener, counselor, and member of the band. Never settling for less, she always made us look great on stage by finding, or sewing herself, the perfectly coordinated stage outfits. And she's always helped us to stay focused. One of her classic comments was, 'Well, you can either scoop ice cream at Cold Stone, or play your guitar and make money.' My mom is the best!

After a while, we all realized that we didn't want to play in just a surf band for ever, and none of our friends were really into the surf music thing that much. We decided to start writing new songs with vocals, and Starlie was the perfect lead vocalist. Our influences were all over the board. We wanted to create a unique and fun sound. And we also wanted to love it. It's been a challenge to create the perfect signature sound for us, but one thing is for sure, we want to keep a surf guitar inspired flavor to our music.

LEVI'S IN HOLLYWOOD

At the time the call came in from my agency telling me that I was up for a big Levi's campaign, I was 14. School was almost out, and I was thrilled about the idea of hanging out with my friends and 'kind of' staying out of trouble. I still had a respectable stash of firecrackers, bottle rockets and Roman candles left over from last year's Fourth of July in Montana. Although doing the holiday Gap campaign with my sisters was totally fun, and the shoot with Hedi Slimane for *Vogue Hommes Japan* was great, I just wanted to have a rad summer filled with friends, skateboards and running around with my shirt off. Modeling was definitely NOT on my mind.

Mimi called one day and told me that I was on a strong option for a Levi's campaign shooting in LA. She didn't have a lot of details at the time, but at least they seemed real interested in me. She also said there were a couple other guys they were looking at and trying to make a decision. I think it was the next day when she called again and said that the Levi's people were getting close to making a decision, but needed a couple things from me. They wanted a video of me playing the drums and some new digital pictures. I guess 'digitals' used to be called 'polaroids' in the modeling world. Sometimes clients want to see a very recent picture of you before they make a final decision. So, my mom and I went outside to the front porch where the light was good and snapped some pictures on her iPhone. I wasn't quite sure what they wanted me to do on the drums for the video, so I just did some kind of a solo for about 30 seconds. My dad thought it was pretty cool, so we sent that, too.

Everyone in my family was like, 'Wow, can you imagine what that would be like to get a Levi's campaign?!' I was

definitely feeling the excitement and all that but, still, at 14 years old, I'm not sure I really understood what a big deal it was. I knew Levi's was iconic. Actually, I probably wouldn't have used the word 'iconic' at that age. But I knew they were huge. I loved Levi's! I wore them every day with my standard big rockabilly cuffs and worn-out Chuck Taylor's. I was perfect for Levi's!

A few days later, I was confirmed for the campaign. I was so stoked! I would be going to Los Angeles again. Unbelievable. And, hey, I could get out of school, too! I think we had just a day or so to hurry and be in California for the shoot. It's pretty typical that once you book a job, it usually starts right away. It seems like the whole fashion industry is so last minute with decisions and timing.

Early the next morning, my dad and I were on the road heading to Hollywood. We drove all day, stopping only in Vegas to grab something to eat. Money was pretty tight at the time, so we planned to stay with Pete, a long-time friend of my dad's. I remember wondering on the drive if this Levi's job was just the beginning? Were there more jobs and opportunities to come in the future? I mean I

knew that people had a lot of interest in me, but there was no way of knowing what lay ahead. As we were pulling into Los Angeles, my dad said, 'Hey, I got an idea ... Let's just drive straight to the beach and get our feet wet!' So we did. The weather was beautiful and it definitely smelled like California. We found a parking lot, took our shoes off, and ran to the shore. I love the beach. It felt so good to be there.

We finally got to Pete's apartment in Culver City. There was a nice air mattress on the floor waiting for us. Half the mattress was shoved under the desk because there wasn't a lot of floor space – it wasn't the most comfortable sleeping arrangement but it was real. It was fun. The three of us went to dinner and the conversation was filled with all kinds of thoughts and guessing about what the next day would bring.

This was a big Levi Strauss campaign. The theme was 'Encouraging the dreams of youth' – to go forth and make your mark in the world. The whole campaign was shot in different major cities across the country. I was to be the kid in Hollywood, but I had no idea what they had planned or what to expect. I had a 6.30am call time, and the craft service truck was ready and waiting with a great breakfast when we arrived. I usually fight having breakfast, but my dad made me eat something because it was looking like a huge day ahead of us. I've learned that in so many of my shoots, you gotta eat while you can. Depending on how many looks they have planned, it can be several hours before you get another chance to eat.

After breakfast we found the wardrobe room and the main people we needed to meet to get started. I couldn't believe the amount of clothing and shoes and accessories that were there. It seemed like pretty much every cool

thing that Levi's had made in the past 50 years was there. Rack after rack of stuff. There were sewing machines, fabrics and people who looked like they definitely knew what they doing with a needle and thread.

And that's where I met Len Peltier. Len was a vice president and the global creative director of Levi Strauss. And he was also the one shooting the campaign. Len was so cool and seemed really excited that I was there. I felt very welcome. As we were standing talking, Len asked, 'Hey, do you know what we're doing today?' My dad and I looked at each other and said, 'No, not at all.' With a big smile on his face, he told us that we were going up to the Hollywood sign where I would be playing the drums overlooking

I WOULD BE PLAYING THE DRUMS
OVERLOOKING HOLLYWOOD

Hollywood. I couldn't believe it. That sounded so amazing! My dad looked stunned, and the rest of the day I saw him shaking his head in disbelief.

While I was getting prepped for the shoot, my dad had more visits to the craft service table than he probably needed. I tried on several things that they had in mind for me. But what was funny is that they finally decided to use the same pants I walked in with – my own Levi's. And my old Chuck's! Before I knew it, we were in a van headed up to the sign.

It took about 20 minutes of winding through Hollywood neighborhoods before we took the last stretch of road up to the sign. I didn't really know what expect, but it was different to how I had imagined. We got to the top of the hill and parked the van on the side of a small, paved street.

Next to the street was a fence that overlooked the sign. The Hollywood sign was huge, and the view of Los Angeles was amazing. It was slightly overcast, but good lighting for a shoot. On the other side of the fence, where the hill dropped down toward the sign, was a small, flat strip of dirt. And on the strip was a drum set! It looked so cool with the view of Hollywood behind it. There were about 15 crew members with all kinds of lighting and cameras and gear. It looked pretty intense.

Now, as all this was happening, there was a decent-sized problem brewing that my dad was frantically, but very silently, trying to solve. Here's the thing: I was technically a minor and a child performer. And, with being a minor, you have to have a special work permit for modeling jobs. I guess you are technically supposed to have it for every job, but with most jobs I'd done, they'd never asked about the work permit. But not this one. Not a big campaign like this. And especially for a big company like Levi's who don't mess around. And guess what? I didn't have the permit.

When we had gotten to California the night before, we didn't have time to get the permit. When we showed up in the morning, people were immediately asking for it. My dad tried to buy some time by telling them that we accidentally forgot it at our friend's apartment and that our friend, Pete, was on his way over with it. It actually was Pete who saved the day. When they started asking for the permit again, Pete raced over to Van Nuys to the permit office. He ran into some problems while at the office and had to do some fast thinking and talking to sort it out. Somehow, between my school and my mom in Utah, he pulled it off and got the permit. He brought it over to the studio at the end of the day, and everything was cool. Barely.

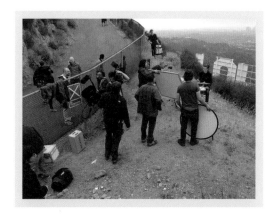

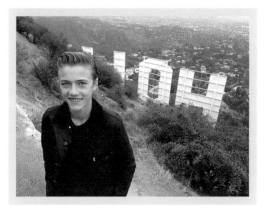

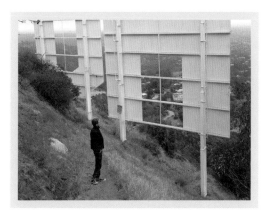

Back at the Hollywood sign, Len gave me a rundown of the plan and we started to get busy. We began with me playing the drums with cameras swarming around me. I wasn't sure what to do exactly but they kept saying, 'Sounds great! Keep going!' We then did some video interviews and still shots right there at the drum set. Next, we decided to go down by the sign and shoot all over the hillside. It was actually a pretty steep hill. Near the top, we had to use a rope and kind of back down slowly. My dad said something like, 'Hey, if you're too scared to do this, we can just call it off. Or maybe I can hold your hand on the way down?' I think that's when I punched him on the arm.

There was a small foot trail around the bottom of the sign. We spent the next hour or so climbing around the hillside taking different shots. Len was really fun to work with. My dad got tired of following us round so he started to look for pieces of the old original sign to smuggle home. He may or may not have found a really cool big old screw attached to a small piece of wood with faded white paint. And he may or may not have got it only barely shoved into his pocket so that it painfully poked his stomach, causing a little bleeding when we climbed back up the hill.

It was an awesome day! Everyone seemed to really like how it went. I loved every part of it: the road trip, sleeping on the floor, and seeing stuff that most people don't get to see. Even though money was tight and we didn't have the most glamorous place to stay, I realized that circumstances don't have to be ideal to do something amazing. A few months later, the campaign hit. It was so fun to see it come out all over the media. One day we found a billboard in Hollywood and I figured out a way to climb up and get a picture. I gotta say, it felt totally cool.

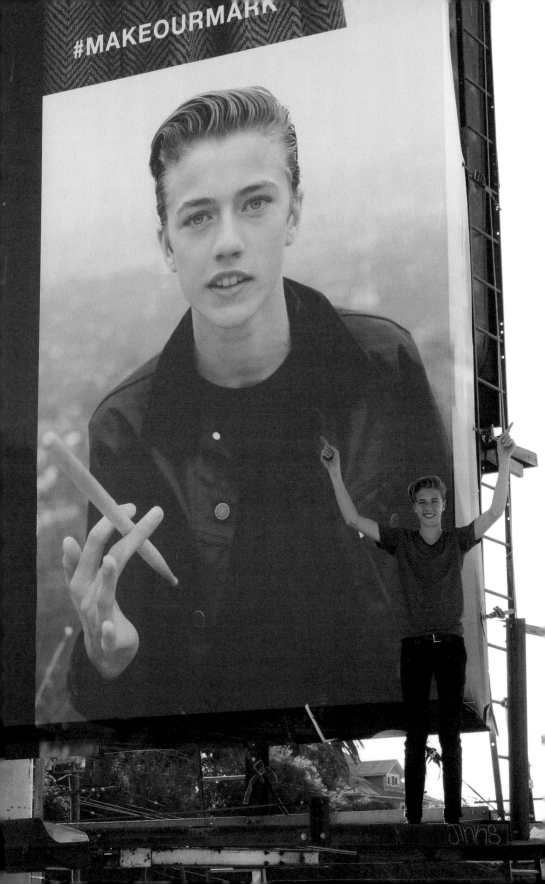

MOVING TO CALIFORNIA

After our original meetings with NEXT, and many trips to LA for modeling jobs, it became obvious that, one way or another, my family needed to move to Los Angeles. NEXT would tell my mom all the time, 'If you guys just moved out here, we could find a lot of work for you.'

Initially, the idea of moving seemed crazy to my parents. The business my dad had started was not going as well as it needed to. He had to find a regular job. And starting out in a regular job never really paid enough, so he was always trying to scramble to make ends meet. Financially, times were tough, and getting tougher every month. So, moving to California with no job, no consistent income, finding a place to live that would be, at best, half the size of our current home for three times the money, and starting over from scratch ... well, it didn't seem like a good idea to my

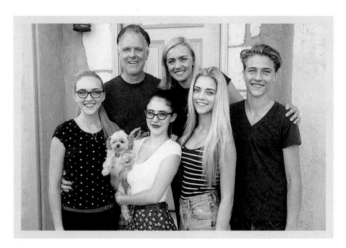

THIS WAS TAKEN ON OUR FRONT PORCH IN SPANISH FORK, UTAH. WE HAD BEEN PACKING AND CLEANING UP ALL DAY. THIS WAS THE LAST THING WE DID RIGHT BEFORE WE LOADED UP IN THE CAR, THE BEAR VAN AND THE MOVING TRUCK TO HEAD TO HOLLYWOOD.

parents at all. There wasn't even enough money for a moving truck, let alone first and last month's rent on a house in Los Angeles. But the small modeling jobs kept coming in and interest in the Smith family kept growing fast.

My parents knew deep down that moving to LA needed to happen. It weighed heavily on their minds that there was no future for us in Utah. They spent a lot of time talking about it and praying about it. My dad wanted so badly to be able to provide for the family, but he couldn't really see a path for that in Utah, and, at the same time, there was absolutely nothing for him in California. All my parents really wanted was for us kids to be able to chase our dreams and have an incredible life.

One day, my dad got a new sales job near Salt Lake City. I don't really know the details about it, but somehow an opportunity came up to become the outside sales rep in Los Angeles. My dad jumped on it. This was the first time we saw even a glimmer of hope that we might actually move to LA. It seemed like all the right pieces might be falling into place.

Because of all the unknowns, the lack of money and the difficult timing, my parents knew this move was going to be a long and bumpy road. However, they came to know one thing deep down inside – moving to Los Angeles felt good, and it seemed like the right thing to do. It might seem totally crazy, the 'how to' might look pretty sketchy, but it felt right. And there would be many times over the following six months when we would need to lean on our faith and the fact that we were all convinced that it was the right decision.

At the end of March 2013, right before we were about to pull the trigger and put everything in motion, my mom

called Jennifer Powell at NEXT. She said, 'Hey Jen, we're all planning on moving down there. I just wanted to double-check with you. Are you really sure we should do this?' Right then, Jen held the phone out to the office and asked everyone in the room if the Smiths should move to LA. They all shouted, 'Yes!'

My parents sat us all down in the living room for a big 'Ok, we're doing this thing, so let's talk' meeting. My dad explained to us clearly and, to be honest, somewhat obnoxiously, that the next several months would probably be the most challenging ever. He said all kinds of encouraging things like, 'Los Angeles will kick your butt and then some. You have to be very tough to live there. It's an absolute night and day difference from little Spanish Fork, Utah.' And 'Hollywood is NOT the city of dreams ... It's the city of broken dreams. It will eat your lunch and not leave a tip.' And 'The sidewalk of Hollywood Boulevard is plastered with stars AND broken hearts.' Finally, Starlie spoke up and said something like, 'Dad, why are you being such a downer?!' And that was followed up with other comments from us kids like, 'Yeah, what a Debbie Downer!' 'Why even go if it sucks so much, Dad, wow?!'

I know Dad just didn't want to get our hopes up too much, but after his generous reality check, the meeting got really exciting and positive. My mom told us about her great conversation with Jennifer, and we talked about all the things we could do to make it work. Mom said that things in California would be very unconventional for our family. We would need to have an 'all for one and one for all' mentality, and do whatever it took to make things work. We would have to pool all money coming in from every direction to make it possible. So that was it! The

Californian dream was now in motion! We set fire to all bridges behind us, and moved forward with a fury.

Dad moved to LA immediately for his new outside sales job. He was able to move right in with Pete Anderson. Pete was a very good, long-time friend of my dad's and the family. We all loved him. Dad and I had stayed with him in his apartment in Culver City when we did the Levi's campaign. My dad slept on the air mattress on the floor again, with half his body under a desk and the other half in the middle of the bedroom. But it didn't matter. It was all part of a bigger plan. My dad lived there for three months doing the sales thing, and sometimes commuting back to Utah to help pack boxes. He didn't complain, but I knew it wasn't easy on him.

NEXT had a model's apartment in Hollywood that they had been using for years. A model's apartment is very typical in the industry. Depending on the size of the modeling agency, they will usually have a few apartments available so a model can rent a room for any given amount of time. It might be one day, a week or a month, whatever. It's very convenient for the models, but you still have to pay a daily fee. Models from around the world are constantly going in and out of these apartments. Around the beginning of July, the NEXT apartment had a lease that was about to end, and they had to decide whether to keep it or not. They offered it to us, if we could commit to Daisy and Pyper moving in right away. And, of course, my dad could move in with them.

This was a huge piece of the puzzle. It allowed us to move there and hit the ground running. The location could not have been better. The apartment was right in the heart of Hollywood, half a block away from the Chinese Theatre,

in between Hollywood Boulevard and Sunset. In and Out was only 14.3 seconds away. How could it get any better than that?! It was an enormous blessing for us, because we didn't need to come up with the usual fees and moving costs. Huge!

On 8 July, 2013, Daisy and Pyper crammed every possible thing they could into our Kia, and drove to Hollywood. It was the first time they had been on a road trip without the rest of the family. It was one of those super hot days and, when they hit the desert, it got a lot hotter. Their car actually overheated around Baker, Nevada, because of the heat and heavy traffic. Never drive to Los Angeles from Las Vegas on a Sunday afternoon. The traffic is crazy bad.

HOW COULD IT GET ANY BETTER THAN THAT?!

The apartment had two bedrooms and, although the girls were excited to be in Hollywood, the apartment was a little shocking. Because it was a model's apartment and no one really cared about keeping it nice, it was totally dirty and hammered-looking. It looked like it had not really been cleaned since the 1920s. They were pretty grossed out. Another thing that hit them was, how in the world was our whole family going to fit in that apartment?! After a couple days of scrubbing and scrubbing, the girls and my dad finally felt comfortable enough to walk around barefoot, use the bathroom normally, and make food in the kitchen. Oh yeah, the first morning, the girls opened the door of the

apartment to go outside, only to find some strange guy had passed out right in front of the door! Welcome to Hollywood.

The rest of the summer in Utah, it was just me, Starlie and my mom packing boxes, sorting through everything, doing a few garage sales and making countless trips to the Goodwill. Although my parents were thankful for the opportunity to move into the Hollywood apartment, it was definitely temporary. Maybe three or four months, or less – just enough time to find a house we could rent or buy that would fit everyone. So, in getting ready to move, we put about 90 per cent of everything we had into a storage unit in Spanish Fork.

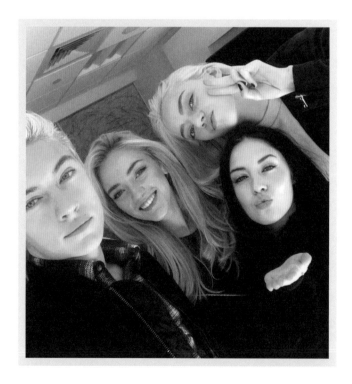

My dad continued to go back and forth from LA to Utah to help with the move, while the girls stayed in Hollywood going to all the castings they could get their hands on. A typical model in LA will go to between three and five castings per day. The casting calls come from the agency either the night before, or throughout the day. It's definitely expected that you do not miss them. Sometimes Daisy and Pyper would have the same casting so they could go together, but it's not exactly an easy life. Yeah, it's great when you land a good job, but 90 per cent of the time your life as a model is filled with rejection. You spend a lot of money and time driving around to castings that go nowhere, building your portfolio and figuring out what will make you different to the next model.

On Memorial Day Weekend, at the end of August, the big moving day came. My dad and the girls drove up, and it was game on! It was finally happening. For at least five months our family had been split up in different ways, trying to make this happen. The Bear Van was loaded full of music gear and we rented a small moving truck filled with just the basic living stuff for the apartment. It was awesome! We were on our way.

I learned many valuable things from the move to California but maybe the most powerful is realizing what can happen when you set your mind to something with a strong intention of making it happen. If your intention is backed up by action, it's amazing how things will start falling into place. Looking back, and talking to my parents about it, I can really see how it all worked together. What seemed impossible at first became possible. And then it became a reality. Yeah, it took a long time, but we made it happen.

LIFE IN
HOLLYWOOD

’m pretty sure that every single thing about living in Hollywood was different to living in Utah and Montana. For starters, gas was a lot more expensive. Restaurants and movies were more expensive. You couldn't just drive up to the movie theater 10 minutes before the movie started, park out front and think you're getting right in. Everywhere you went had to be planned out around traffic times. You actually made decisions about going to this place or that based on what the parking situation was going to be like. Going to the grocery store was a big hassle – parking was a nightmare, they charged you for each grocery bag, and then when you got home, someone had to meet you in the garage with a cart to bring everything up in the elevator. The days of 'Hey, I'm gonna run down to the store real quick, I'll be right back' were over.

THIS IS A RANDOM PHOTO THAT PYPER TOOK ON THE PATIO IN OUR APARTMENT BUILDING. PYPER LIKES TO TAKE PHOTOS AND MESS AROUND LIKE THAT AND SHE IS GOOD. ONE TIME SHE TOOK A PICTURE OF ME THAT ENDED UP IN MY BOOK AT NEXT.

But I loved it. I loved living in Hollywood. I even learned how to drive there. And seriously, you have no idea what driving under pressure is until you have driven in Hollywood. It's so 'game on' there for driving. At home, our living arrangement was tight. Six people, one dog, a truckload of instruments . . . all in a two-bedroom apartment. Need I say more? Here's the layout – all the kids took the master bedroom and my parents got the small room. And, believe me, it was small. We didn't bring any bed frames, so we only had mattresses in our room; one queen, one full, and one old twin that was left over from the models before. Unfortunately, I was stuck with the twin. The girls did a rotation with the other two mattresses, so you didn't always have to sleep with someone else. And, let me just say,

SIX PEOPLE, ONE DOG, A TRUCKLOAD OF INSTRUMENTS... ALL IN A TWO-BEDROOM APARTMENT. NEED I SAY MORE?

Pyper is a crazy sleeper. If you're not careful, you could get hurt sleeping in the same bed with her. Each of us also had our own set of shelves that we could put all our personal stuff on.

Technically, I was still a high school kid, so we had to figure out how to make that work, too. The good news was that we lived about 43 steps away from Hollywood High School. Literally. The bad news was that as things started to get really busy for me, which pretty much happened the day we moved to Hollywood, there was no way I could attend a regular school with a regular schedule. We had to

MY AGENT MIMI CALLED AND ASKED ME TO TAKE SOME
SELFIES SKATING OR DOING SOMETHING I LIKE TO
DO. I DON'T REMEMBER WHAT IT WAS FOR BUT THESE
ARE A COUPLE THAT I CAME UP WITH.

find another solution. Maybe this will help paint a picture – during 2015, I was home roughly 60 days.

My mom ended up finding a school called City of Angels in the LA School District that specialized in dealing with child performers and home-school situations, which was perfect for me. We would go downtown to the school once a week and check in with my assigned teacher, Sal DaVila. He was great; I really liked him. I would bring home packets of homework to do that week, and go back to school for testing, if needed. The best part of all was the Physical Education class. I made a deal with Mr DaVila that I would ride my skateboard every day and tell him about it. So every day I rode my skateboard all over Hollywood Boulevard,

SO MUCH HAPPENED DURING THAT TIME. IT WAS AN ABSOLUTE WHIRLWIND FOR EVERYONE

dodging in and out of the tourists walking around the stars of the Hollywood Walk of Fame for P.E. The crazy people were awesome to watch. It never got boring. There was always something cool going on. It was the greatest P.E. class in the world.

The three-to-four-month apartment plan turned into about two and half years. So much happened during that time. It was an absolute whirlwind for everyone. I met and worked with some incredible people. My life got busier and busier. The Bear Van was sold to some Hollywood band. Pyper graduated from some high school in the Valley. I did countless jobs all over Los Angeles. I traveled the world and

filled up an entire passport in about eight months. I was one of the leads in my first movie, *Love Everlasting*. My grandmother, Bema, passed away. I got my driving license. I was a guest on *The Ellen Show*. Magazine covers, tons of fashion shows, and on and on . . .

Hollywood was amazingly good to me. I know that I have been very blessed and very lucky. And if it weren't for my parents, my sisters, Mimi, the incredible global team of NEXT, and many other good people, none of this would have happened. I'm truly grateful.

I KNOW THAT I HAVE BEEN VERY BLESSED AND VERY LUCKY... I'M TRULY GRATEFUL

THIS IS THE DAY I GOT MY DRIVING LICENSE. IT FEELS GREAT TO BE ABLE TO DRIVE YOURSELF PLACES - IT'S A NEW KIND OF FREEDOM.

This was when I first bleached my hair out for the *Interview* magazine editorial. It was done the night before the shoot in a hotel on Sunset Boulevard where the hairstylists were staying. When I got to the shoot the next day they bleached my eyebrows and it looked so strange to me. I didn't really like it, but I thought the story in the editorial came out cool. I had them dye my hair and eyebrows back at the end of the day.

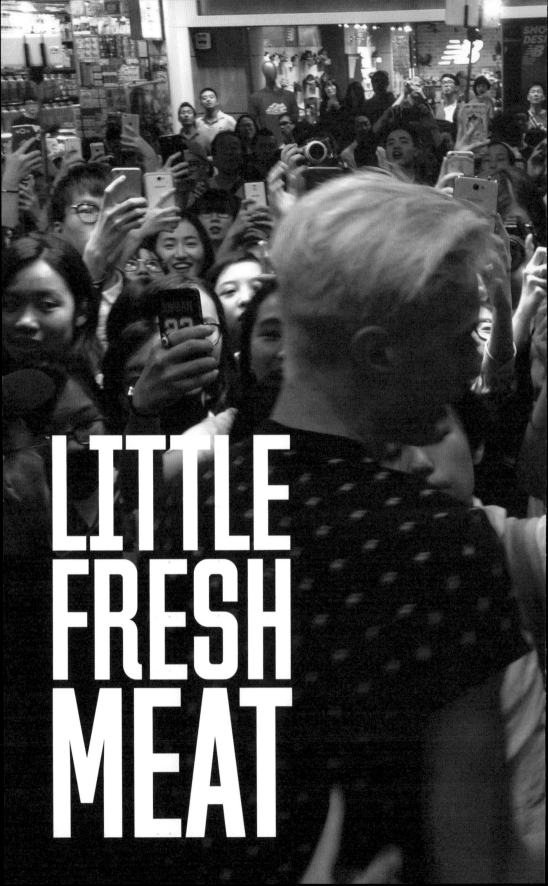

LITTLE
FRESH
MEAT

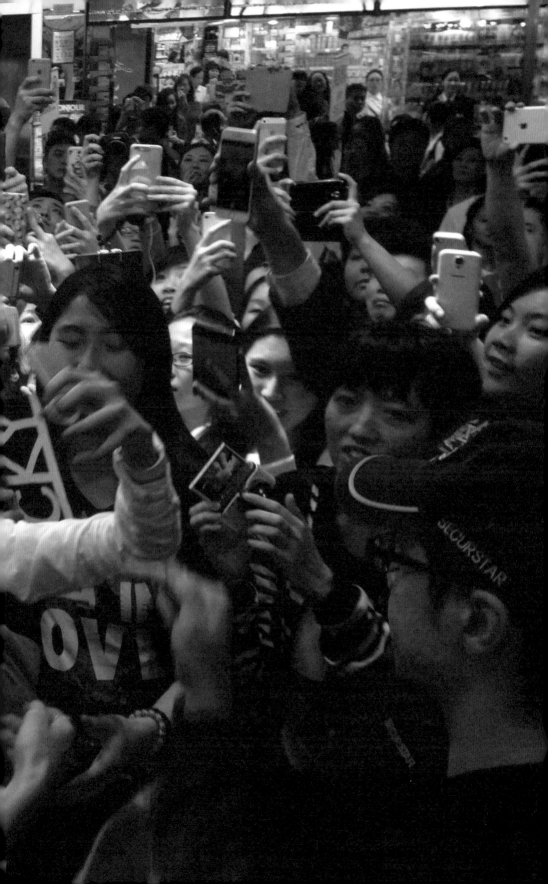

H ey, Lucky, you've got to check this out!' My dad grabbed his computer and showed me a video of some TV talk show in China that had a huge picture of me in the background while the hosts were obviously talking about me. Then he showed me another, and another. Then we went on Baidu, the Chinese equivalent to Google, and typed my name in. We couldn't believe what we saw. My name was all over the place with countless pictures and videos. Obviously, we couldn't read anything, but it was very clear that China knew who I was. We also noticed that my name was heavily surrounded by the phrase, 'Little Fresh Meat'. I wasn't sure how I felt about that one but seeing all of it was unreal.

MY NAME WAS ALL OVER THE PLACE WITH COUNTLESS PICTURES AND VIDEOS

I had been noticing a pretty good jump in my Instagram numbers around that time, and comments written in Chinese were definitely growing. But I really didn't think too much about it – there were comments coming in from a lot of different countries.

My dad knew there were some Chinese exchange students living in our apartment building, so he went down to the building manager's office to find out what apartment they were in. When we got the apartment number, we went upstairs and knocked on their door. We wanted to find out what was being said about me on Baidu.

A couple kids answered the door and looked really confused, wondering why we were there. I felt

uncomfortable asking questions, but my dad had no problem with it. After confirming they were in fact Chinese, and asking nicely if we could talk to them, my dad whipped out his laptop. They still seemed a bit leery, but intrigued. We showed them the Baidu pages and asked if they could help us figure out what was going on with me in China. A couple of the guys read for a minute, then simultaneously covered their mouths with their hands, opened their eyes really wide, and said something like, 'What, is this you?!'

They told us that I was very, very popular in China, and that everyone was talking about me. They said 'Little Fresh Meat' was a positive thing. It meant that I was the new young fresh thing in China, and kind of like people wanted to eat me up. I'm sure it was hard to translate into English,

but I got a sense of what it meant. It was pretty funny to hear them explain it.

So, I think this is what happened ... Some time during my first fashion week season, pictures of me modeling and walking around the city were leaked to China. From what I understand, and I really know nothing about it, China has very strict regulations on global Internet access. Apparently, very little makes it into mainland China. But, somehow, I snuck through. Oh yeah, my skateboarding around Hollywood Boulevard routine included stopping for pictures with people from China.

We showed NEXT everything that was going on in China and they agreed that something crazy was happening over there. One day, interest came in from Adidas China. They wanted to bring me over there for a campaign and some appearances. Before long, an awesome deal was in the works, and a trip to Shanghai and Hong Kong was right around the corner. The plan was for me and my dad to go together, and Alexis would come with us. We had to get our Chinese traveling visa quickly before we left. After a lot of paperwork, paying for expediting, and crossing our fingers, we were able to get 10-year visas. That was amazing!

Then Cathay Pacific airline singlehandedly ruined flying for me. I was fine traveling around the country and world on various airlines in economy or economy plus with an occasional business class seat – what I didn't know, didn't hurt me. But the minute I boarded the Cathay Pacific plane and, instead of turning right on the walkway with the rest of the line, I turned left toward the flight attendant with the better hair and bigger smile, and found my business class seat – actually not a seat, more like an amazing flying

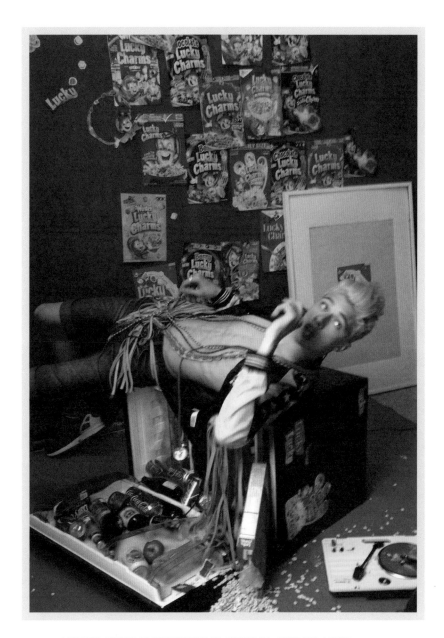

VINTAGE-INSPIRED PHOTOSHOOT IN SHANGHAI. THEY HAD LUCKY
CHARMS CEREAL BOXES ALL OVER THE WALL.

OVERLOOKING HONG KONG WITH MY DAD. I HAVE WAY BETTER HAIR.

station – I was done. Flying would never be the same again. Cathay Business Class was beyond incredible. Next level. That flight caused me to become a business class snob. Yes, I turned into 'that guy'. And my dad is still seeking therapy to deal with having to fly with other airlines.

We knew that people from Adidas were going to meet us at the airport, and that they had arranged security. But nothing could have prepared me for arriving in Shanghai and Hong Kong. It was unbelievable. As we were going through immigration in Shanghai, I guess they had a video camera that showed whoever was in the line to the outside waiting area. When I walked past the camera, we heard an enormous roar of screaming girls. We all looked at each other in shock. A few minutes later, the doors opened to the terminal. It was out of control to say the least.

There were so many people there to greet me. I just couldn't believe it. I have no idea how many. Several hundred? A thousand? Who knows? All I know is that it was overwhelming. About 10 security guards tried to

make a barricade around me, but we all just got smashed together. My dad and Alexis were immediately pushed out of the way, and there was constant screaming, girls grabbing and touching me. We could hardly move. Finally we made it to the escalator heading to the exit. My dad got separated from us, but somehow made it through. I have no idea who took care of our luggage. We barely made it to the car, but it didn't stop there.

These girls were organized. The second we were in the car – wide eyed and shaking our heads in disbelief – we noticed a whole different group of girls, maybe 50 of them, had split up into separate cars and vans with professional

THE ADIDAS TEAM WAS AWESOME.
THEY WERE SO ORGANIZED, SO NICE,
AND SO GREAT TO WORK WITH

drivers. As we drove away from the airport, they were right with us! They followed and swarmed around our car like bees all the way to the hotel, taking pictures, showing me handwritten posters and heart signs, and blowing kisses. It was absolutely unreal – and so much fun! For the next five days, no matter where I went and no matter what time of day, I was followed and chased down by mobs of girls.

The Adidas team was awesome. They were so organized, so nice, and so great to work with. The schedule was very busy and action packed, but they made it a lot of fun. The store events were a blast. There were tons of people at every event and a lot of excitement. Adidas was also very creative with contests and games. I even did a drum solo using a pair of shoes as sticks.

There was one day that was especially great. And it was a long one! We had an early start in a good-sized studio inside a big building. I'm pretty sure we started around 7am. I don't know how they organized it all, but it was brilliant. When I walked into the studio, I noticed one side of the room had a huge amount of Adidas clothing and shoes stacked up and hanging on racks. It seemed like there was about 12 people running around getting ready for the day. All the lighting was set up and a lot of backdrops to choose from.

Adidas lined up, for this one day, about 30 or more different types of media companies to come in with a small crew, do a short shoot and then interview me. There were television networks, radio stations, magazines, and other types of crews. It was seriously impressive. They were each given a 30-minute time limit. One crew at a time would come in and get set up. During their set-up time, I would quickly change into a new set of Adidas clothing and shoes, and the hair and makeup team would try to do something different with my look. When everyone was ready, we started with a quick photoshoot. After that, we'd grab a couple chairs, and I'd sit and do an interview with them. When that group finished, the process would start all over again with a new crew. I think we did about 33. Crazy!

It went on all day and into the night. I just had to make sure I had energy and enough things to say. When the last group was done, they opened it up to about 20 photographers for a kind of free-for-all thing. That lasted about 30 minutes. Everyone was great and very professional. I was completely worn out by the end of the day, but it would be really difficult to put a price tag on the media coverage I got.

Another great experience I had while I was out there was at an enormous shopping mall that was putting on a big

event and fashion show for *Harper's Bazaar*. The mall was four storeys high and filled with people. There was a big stage set up in the middle of the main area, and a ton of media all around. The owners of the mall were there with all kinds of people in the fashion industry. It was a bigger deal than I originally thought it was going to be. I was the main guest of honor, and was expected to give a speech and a kind of blessing on the day, or something like that. I, of course, had no idea whatsoever what I was going to say.

For the fashion show, I sat up front with my dad and Alexis to watch the show. When it was over, they took me backstage to prep me for the rest of the event. They had a great translator for me so it was no problem communicating with anyone. It was pretty fun. I was the judge for a hat contest, we played some games, and there was time for some questions and answers with me. I never actually did any kind of a speech or blessing – either they changed their minds, or I missed the boat somehow. I don't know. But it was a great event.

Something else also happened soon after I stepped on to the stage that was a good learning experience for me.

It's probably not a big deal for most people but, for me, it meant something. As they were introducing me to the crowd, two beautiful girls walked over holding trays of Champagne. I thought to myself, 'Man, I hope they're not bringing that over for me.' But the translator was filling me in on everything they were saying. And yes, it was for me.

The main guy was saying something like, 'In celebration of Lucky Blue coming to China, we would like to propose a toast and share this Champagne together . . . ' Then everyone on stage took a glass, except for me. Now, you have to understand, all this was happening within seconds.

THIS IS A BEHIND-THE-SCENES SHOT OF A COOKING SHOW I WAS ON. MY FAMILY THOUGHT IT WAS PRETTY FUNNY BECAUSE I DON'T REALLY EVER MAKE FOOD FOR MYSELF AT HOME. I EVEN TRY TO TALK MY MOM OR SISTERS INTO MAKING MY TOASTER WAFFLES.

And it was a ton of pressure weighing on me. I could clearly see that having a sip of Champagne with their special guest was a big deal and important to them. But this was not just a problem because I had never drunk alcohol before. No, I was a Mormon kid. And so I don't drink. At all.

I'm sure that it would have been understandable if I had taken just one tiny sip, or even if I had faked like I was drinking it. And I know that most people would say that it was a special circumstance, and that I didn't really have a choice – you don't want to offend them, so it won't hurt anything. All that stuff raced through my mind in an instant. But I did have a choice. I had a choice to be true to my commitment not to drink alcohol, or I could be weak and not true to myself and what I believed in.

As they were all waiting with smiles for me to take a glass, I leaned over to the translator and told her that I didn't drink. She seemed surprised and said, 'It's ok, just take a glass and hold it up.' Then I told her, 'No, sorry, I don't want to have anything to do with alcohol.' She said she understood and relayed the message to the main guy. He then said something to the crowd with a big smile, and everyone took a sip, except for me. In the end, it turned out ok and I felt so much better than I would have if I'd been untrue to myself. It showed me that I can be in a difficult situation and still be strong and stand up for what I believe in. I am the one who has to live with my choices.

The rest of my time in China was filled with one thing after another. It is an awesome country. I met so many amazing people. I really want to thank the fans and new friends I made there. I tried my best to spend as much time as I could with them. Everyone was so kind and giving. Thank you, China, for giving me such a great experience!

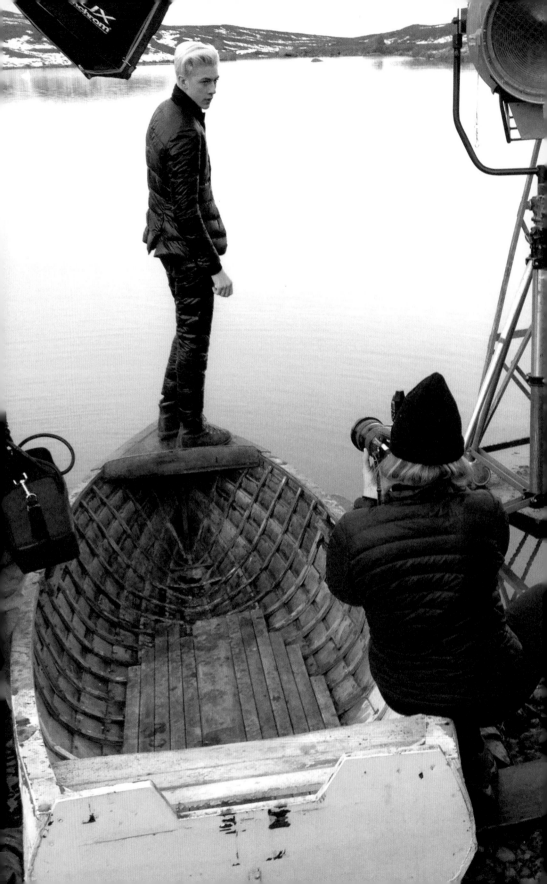

ICELAND
WITH
ANNIE

've been asked this question many times, 'What has been your favorite photoshoot?' I've done many shoots in the past few years, but that's still an easy question to answer ... The Moncler shoot with Annie Leibovitz in Iceland. It was a once in a lifetime experience, and I'll never forget it.

I have to admit, when Mimi first told me about it, I didn't know who Annie Leibovitz was. Hey, I was 16! How was I supposed to know? After about 18 seconds of Googling her, I got it. And every time I told someone that I was going to do that shoot with Annie, they gave me the same kind of look – somewhere between disbelief and jealous excitement. Almost like I'd done something wrong. And the look was usually followed by them saying something like, 'Do you even know who that is?!'

Another great thing about the shoot was that Pyper was part of it. We have a lot of fun shooting together. My dad flew out there with me, but Pyper was coming in from New York on a different flight. We met at the hotel. Flying into Iceland was awesome. It looked amazing. We got there

THE MONCLER SHOOT WITH ANNIE LEIBOVITZ IN ICELAND... WAS A ONCE IN A LIFETIME EXPERIENCE

early in the morning and Thorstein, one of the drivers, picked us up at the airport. He was our driver the whole time we were out there, and he was so great.

We went to a fitting not far from the airport, met a few crew members, then set out on a six-hour drive to our first

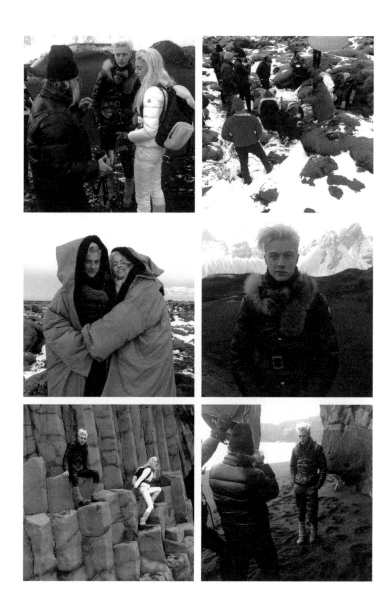

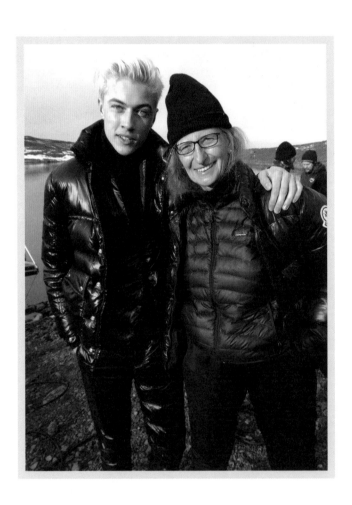

location. I don't know what they were thinking when they named the country Iceland – it is so beautiful. If I had to describe Iceland with one word, it would probably be 'pure'. Everything is just so pure there. The water, air, scenery, and even the people. Everyone I met was so friendly.

Annie was great to work with, and was very nice to Pyper and me. She is a true artist and had a solid vision for what she wanted at every location. She would talk a lot with us, explaining exactly what she was looking for. The theme and story was a fantasy journey about a sister trying to save her brother and escape from an evil ice queen. We each did individual shots, and shots together. I will admit that I was a little jealous when Pyper got to shoot with a beautiful real live Husky wrapped around her neck.

It was pretty cold during the entire shoot, but that didn't even matter. We were able to get a front-row seat to see the beauty of Iceland as we shot in the most incredible locations. We hiked up enormous glaciers with shoe spikes, lay down in beautiful, untouched moss fields, scaled up volcanic cliff walls, explored huge waterfalls where the icy mist went right through us, and walked the most amazing black sand beaches. And for some reason, Iceland's ocean seemed more powerful than any ocean I have ever seen. The whole thing was just amazing. I would love to go back one day.

WE SHOT IN THE MOST INCREDIBLE LOCATIONS... THE WHOLE THING WAS JUST AMAZING

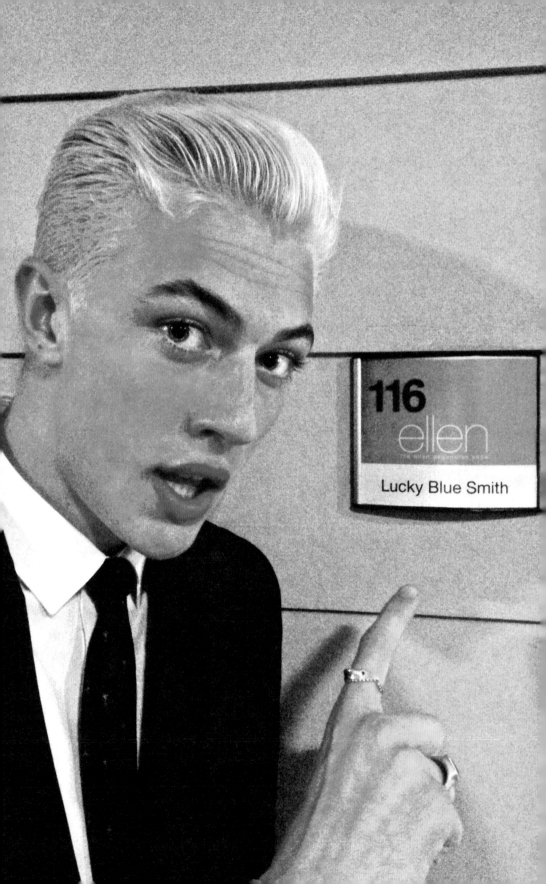

THE
ELLEN
SHOW

One of my very favorite experiences! While I was on a trip to Hong Kong with my dad and Alexis, we got a message that a producer from *The Ellen Show* wanted to talk to me right away about possibly being on the show. Now that seemed crazy. I mean, I knew that things were really picking up for me, but that seemed so next level. One of the first things that came to mind was that she always has people dance on her show. And, believe me, I'm no dancer. So that was kind of a scary thought, if I were ever to make it on the show.

When the call came in, I was at the top of a mountain overlooking the most insane views of Hong Kong. I talked to the producer – she was so nice and fun to talk with.

> I KNEW THAT THINGS WERE REALLY
> PICKING UP FOR ME, BUT THAT SEEMED
> SO NEXT LEVEL

We actually spoke for about 30 minutes. She asked all kinds of questions about me and my family. She wanted to know all about the history of what got me to this point in my career. We talked about meet ups, girls, my hobbies and what I like to do for fun. I thought the conversation went really well, but I didn't get a sense that it was going to happen for sure.

Then, like all other big opportunities and possibilities that come my way, I just put it out of my mind so that if it didn't happen, it wasn't a big disappointment. *The Ellen Show* would have been such a big deal, so everyone around me was on pins and needles waiting to hear. Ok, I was too. It was some time after I got home from China that we got

the call we were hoping for – I got *The Ellen Show*! This felt different from all the other jobs I'd booked. It felt, like, wow. Just wow. Being a guest on an enormous TV show like that was a whole different ball game.

I now had two things I needed to do before the show. One was a no brainer – an Instagram selfie wearing an Ellen t-shirt to announce it. The other was, well, let's just say slightly scary... I had to learn how to dance. And quickly. I had no idea if I was going to have to dance, but there was no way I could go on *Ellen* without some kind of dance prep.

I was in New York with my dad doing a job when I got the Ellen shirt sent to our hotel. They wanted the post to be done on a certain day at a certain time. Being a 16-year-old, I, of course, just pulled the shirt out of the box and threw it on. That's when my dad said, 'Uhhhh, dude, you're gonna have to iron that, right? That shirt is a wrinkled mess.' I said, 'No, no, it's fine.' So, we argued for about 10 minutes. My dad won. We went out and took some good pictures

TALKING TO *THE ELLEN SHOW* PRODUCER WHILE IN HONG KONG.

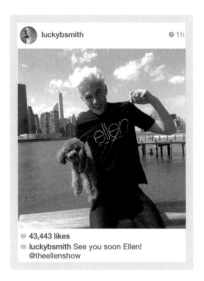

luckybsmith 1h

43,443 likes
luckybsmith See you soon Ellen!
@theellenshow

with the New York City skyline in the background, then
did the posting.

It turned out that the whole family was invited to
the show, so everyone was excited. I couldn't wait to go.
I took some dance lessons, I dry-cleaned my blue suit,
and rehearsed in my mind the perfect answers for all the
possible questions Ellen might ask me. As the big day got
closer, I still didn't feel nervous. I was getting pretty good
with modeling at showing up cold to all kinds of situations.

Finally the day came. It was 20 April, 2015, which, by the
way, was my parents' 25th wedding anniversary. My dad
had been scheming to surprise my mom with something
good. With *The Ellen Show* being on the same day as their
anniversary, it was the perfect cover to surprise her.
With some big help from Alexis and his connections, we
planned an awesome trip to Miami Beach and the island
of Bimini. My mom had no idea whatsoever. My dad knew

something was going to happen, but didn't know very many details. My sisters and I were so excited to tell them.

A nice black sprinter van limo came to pick us up in front of the apartment. We were all dressed up and ready to go. Alexis and Mimi were already in the van and the air was filled with total excitement and, still, slight disbelief. Hollywood to Burbank is only about 20 minutes, so it was a nice drive together. Pulling up at the studio in the big van was so fun. The security seemed real serious at the gate but, once we got in, the driver took us straight to the front door. It was on! And, no, I still wasn't feeling nervous at all.

Some friendly people greeted us at the door and took us straight to the Green Room where food and drinks were waiting for us. Before long a producer came in and introduced herself. She was very helpful, and gave us an overview of what was going to happen. After she left, it was time to tell my mom about the big anniversary surprise. We said, 'Well, Mom, we know that it's your anniversary today. And, because of *The Ellen Show*, it was hard for you

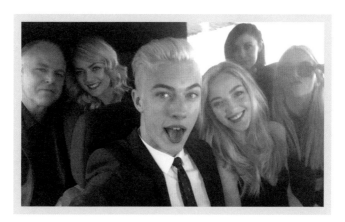

ALL LOADED UP IN THE VAN HEADING TO *THE ELLEN SHOW*. EPIC.

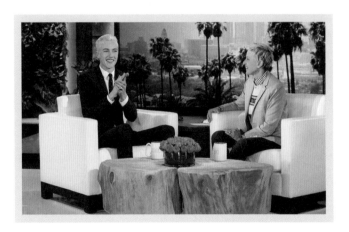

to make any real plans. So we decided to make plans for you. When we get back home today, you're gonna have about 30 minutes to pack your bags, because you and Dad are leaving tonight for the island of Bimini!' My mom looked puzzled, then started to cry when it sank in. My dad teared up, too. It was so awesome to tell them.

During our time in the Green Room, the producer came in to talk with me in private. We went into another room next door. We talked in detail about how everything would go. She brought up ideas of what Ellen might want to talk about, and ideas of what I might want to say. She didn't tell me what to say, but talked about what to be careful of saying. Mainly she told me how the flow of the interview was most likely to go so I was prepared for it. What was interesting was that when we finished talking, she said she'd be back in about 20 minutes to talk again. The next time she came in, we sat in the same room and went over almost exactly the same stuff. And what's even more interesting was that, about 20 minutes later, she came in for a third meeting that was pretty much a repeat of

everything before. I didn't know that was going to happen, but I was kind of glad it did. It helped me feel at ease.

Finally, they came to get me for the show. I left everyone in the Green Room and walked down a hallway toward the backstage area. I took a selfie with an iPad that was hanging on the wall. I think I was only backstage for a couple minutes. Everything was moving so fast. My family was taken to the side of the stage where they waited to be seated. I remember Ellen saying something about sleeping, and she told the audience that everyone was getting a free new mattress. During a quick break, they sat my family in some empty seats near the front.

I was standing there, ready to walk on to the main stage, with instructions to smile and wave as I made my way toward Ellen, hearing an actual count down, '5, 4, 3, 2, 1 . . .' and I had a strange sensation come over my entire body. A wave of nervousness like I'd never felt before. It hit me like a freight train. But there was no turning back.

What an amazing feeling it was to walk out and sit with Ellen. She made me feel comfortable, but it was still a lot to take in. I remember starting out nervous and talking fast, but I kind of got to the point where I felt like I could relax a bit. I loved it, though, and will never forget it. It was an incredible experience. I hope to meet her again some day.

After the show, we raced home so my parents could pack for their trip and make it to the airport on time. But they weren't the only ones leaving the country. I had booked a big Tom Ford campaign in London, and was leaving that night as well. And Starlie was going with me. Luckily, my parents' flight and my flight were leaving around the same time out of LAX, so we all took off for the airport together. What a day!

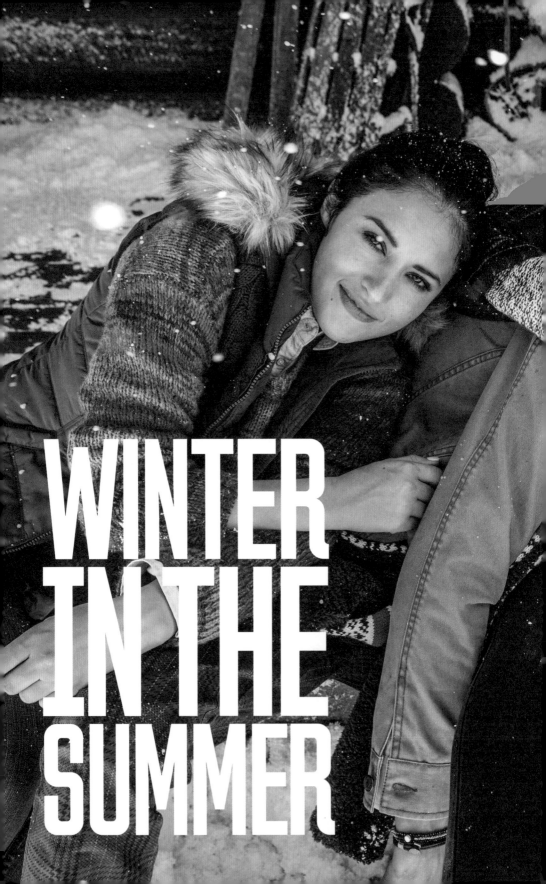

loved the Aéropostale shoot. It was one of the funnest jobs I've done with my sisters. And the photographer, John Urbano, was nothing short of awesome – he was very cool and fun.

We were hired for the Aéropostale Holiday Campaign as The Atomics but this shoot was different from the others in lots of ways...

We made it to LAX with plenty of time to catch the flight and things were looking good. It was me, all my sisters and my dad. We were loaded up with suitcases and guitars because we were going to use them for the 'Christmas party scene'.

THIS SHOOT WAS DIFFERENT FROM THE OTHERS IN LOTS OF WAYS...

Our plan was to catch a flight from LAX to Salt Lake City, then get a connecting flight from Salt Lake City to Jackson Hole, Wyoming. We were due to land in Wyoming around 9pm, and then a car was going to pick us up and take us to the hotel. Easy, right? There was no room for complications because we had a 5am call the next morning. The cast and crew had to leave the hotel that early in order to make it on time to the remote location, which was a two-hour drive away. So it was going to be pretty much 'game on' from the moment we arrived.

Sitting in the LAX terminal waiting to board, we got word that the flight to Salt Lake City was delayed by about 30 minutes. No big deal. But when it was delayed again, we started to worry – we only had a short layover before the

connecting flight. Then, of course, the delays kept coming. And coming. My dad spent a lot of time up at the airline counter trying to figure out if there were other flight options because it was definitely looking like we were going to miss our connecting flight. Apparently there was nothing. By the time we boarded the plane, three hours later, my dad had a new plan.

He called around and reserved the biggest rental car he could find at the Salt Lake City airport. He was going to get us there no matter what it took. The only option was for my dad to drive all night while we slept as much as possible so we didn't look like complete zombies in the morning.

When we landed in Salt Lake City, we split up to get everything ready for the drive. My dad took off with one of the girls to get the rental car and the rest of us waited for our bags. Well, we found some of them but three were missing. We called my dad to tell him the great news. He wasn't happy.

After a couple hours driving the lost baggage people crazy, we finally found the bags. By that time everyone was starving and my dad was freaking out because he was already kind of tired and he knew that the five-hour drive to Jackson Hole was going to be brutal. We loaded up the rental as fast as we could, then looked for something to eat. We finally got on the road about 12.30am. I think everyone tried to sleep the best they could but the main problem was that we only had about four and a half hours to get there for the 5am call time. My dad was going to have to really fly to make that happen.

Amazingly, we pulled up at the hotel at 4.50am. I think the only one of us looking like a zombie was my dad. He said something like, 'You don't even have four seconds

to waste. You have about 10 minutes, maybe 15 if you're lucky, to get ready to go to the location. I doubt you have time to shower, but if you need to, I'd do it in record-breaking time.' So we all scrambled as fast as we could and made it out to meet the crew.

The drive to the location was beautiful. We drove right by the Teton Mountains – so rad! The shoot location was out in the middle of nowhere at a lodge. The coolest thing about it was that we were shooting in summer, it was totally hot outside, but the set was completely covered in fake snow. It looked like the perfect white Christmas winter wonderland scene.

The entire shoot was so much fun. It was great to be doing it with all my sisters. One of the days was spent shooting a video of a big Christmas party with friends inside the lodge. It was all decked out with Christmas decorations. My sisters and I were set up in the corner with our instruments and we played a surf-style Christmas song we'd arranged. We had such a blast. The other days of shooting were spread out around the property doing various looks.

Everything about the campaign was great – the Aéropostale team was awesome to work with, the crew was fantastic. I loved it.

THE ONLY OPTION WAS FOR MY DAD TO DRIVE ALL NIGHT WHILE WE SLEPT AS MUCH AS POSSIBLE SO WE DIDN'T LOOK LIKE COMPLETE ZOMBIES IN THE MORNING

LOVE
EVERLASTING

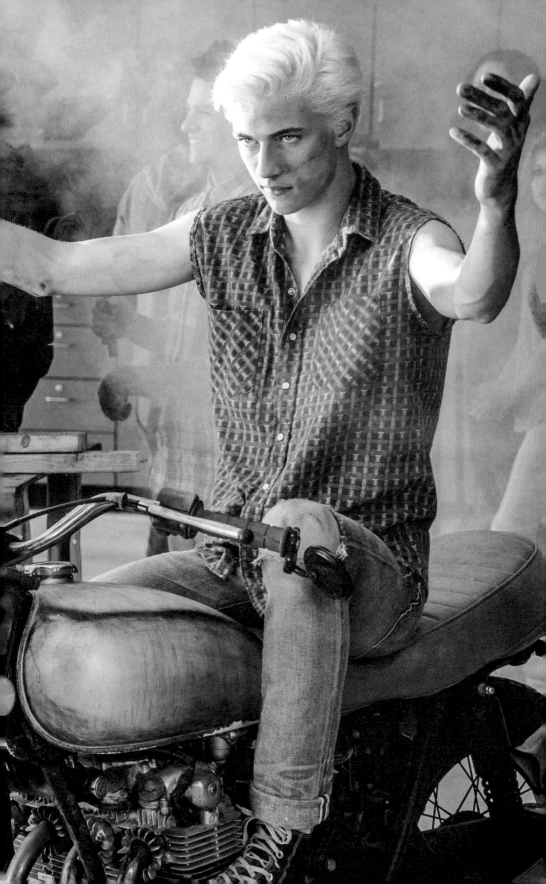

As the modeling started to gain momentum, I started to think about acting. Pyper had always dreamed about being an actress – I think she has some serious talent – but it was never heavily on my radar. I was intrigued by it, but I was so busy doing other things with modeling.

It all started when I was visiting my Bema in southern Utah for Thanksgiving. My dad's very close friend Rob Diamond came over to hang out for a couple days. Rob is an independent film maker, and one of the best guys ever. My whole family loves him, and loves it when he's around. Rob was also a very successful model when he was younger, so we had a lot to talk about with that. It's kind of crazy, but Rob also did a huge Levi's campaign in Hollywood when he was a teenager.

At the time, I had a few hundred thousand followers on Instagram. He knew what Instagram was, but didn't know I had a following. I was showing him how it worked and

what happened when I posted a picture. He was blown away watching all the likes and comments flood in at lightning speed. Then he said something like, 'Hold on here, if I go outside and take a picture of you, and then we post it, are we going to get a lot of comments?!' I said, 'Yeah, for sure, let's go do it.' So we went outside by some southern Utah red rock and took some shots. When we got back to the house, he excitedly announced that he knew now what his next film was going to be, and that I was going to be the lead role!

That sounded really great, but the problem was that I had exactly zero experience with acting. And I was to be the lead? Uhhhh, how was that going to work? We started

I REALIZE THAT NOT EVERYONE WILL UNDERSTAND OR AGREE WITH YOU WHEN YOU WANT TO DO SOMETHING BUT... YOU ALWAYS NEED TO LISTEN TO YOUR GUT AND FOLLOW YOUR HEART

brainstorming ideas and different story lines. It was a lot of fun thinking about it and making a plan. My dad said, 'So, Rob, what if he sucks at acting? He's never done anything like that before.' Rob was completely confident that I could do it. He said he'd put his arm around me for the entire process and pull it out of me. He didn't want me to take any acting classes in LA before the shoot. He was afraid classes might screw me up.

Rob had the script written at record speed, and the story was looking and feeling great. *Love Everlasting* is a story about two teenagers with broken pasts who, together, find true lasting love. It's also about finding real inner beauty

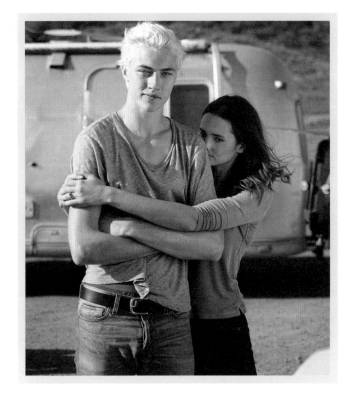

in people, which is very important to me. We talked and brainstormed about other lead actors who would be good. Because of my lack of experience, he wanted to surround me with great, seasoned actors. Christie Burke was his first choice for the lead role of my love interest in the movie. Christie is an amazing actress. We had great chemistry, and she was so fun to get to know and work with. I learned a lot from her. I love her complete passion for acting.

Emily Procter played the role of my mom. She was incredible and humble at the same time. I was watching her closely and trying to learn from her. I loved how professional she was. I'm so glad she worked with us and was a part of the movie. I think we were very lucky to have her. She totally made my job easy. Another lead was Shawn Stevens. I wasn't around at the time, but Shawn was a huge teen idol and actor when he was younger. He's one of the nicest people you'll ever meet. He was great to work with and really added to the movie.

Rob Diamond . . . Where do I even start? Without Rob having the vision and belief in me, I would not have had the chance to be a part of making a movie. He was kind, patient, and passionate. Having had no experience at all with acting, I had him with me every step of the way, and he pulled things and emotions out of me that I had no idea were there. I couldn't believe how great he was to work with. His talent for directing actors and telling a story on film is off the charts. Because of Rob, I quickly learned to love acting and the whole process of making movies. But, aside from acting and movies, Rob is one of the few people I will always seek for help, guidance, and direction in my life. He's not just a great friend, he's family to me.

Here's how Rob tells the story:

ROB DIAMOND It had been a few years since I had last seen Lucky. His father, Dallon, has always been one of my best friends, so I've been around Lucky as he grew up. Lucky is a very talented, polite young man with a heart of gold and was always a nice-looking kid. But nothing prepared me for seeing him as a teenager. One word comes to mind – STRIKING.

I drove down to St George, Utah, to spend some time with Dallon as he was helping take care of his mother. I had been there a few days when Dallon mentioned that Lucky, his sisters and his mother were heading up to St George from LA. I was excited to see everyone as it had been a while. I remember when Lucky walked in. I was taken aback. I think I stopped dead in my tracks. He had grown about a solid 8 inches or more since I had last seen him and stood about 6 feet 2 inches tall with bleached white hair and piercing blue eyes, a flawless complexion and features chiseled from stone. He was lean, ripped, and – like I said before – striking. As a model myself in my youth, and then an actor and now a director, writer and producer, I've been around plenty of good-looking people, but not like this. They say people either 'have it' or they don't. This dude has the 'it factor' all day long and then some.

Lucky's grandfather had a decent camera lying around, so we went outside to shoot in the beautiful St George desert for fun. I'll never forget, one look at him through the lens and I knew that this kid was truly special. I knew that I was seeing a superstar on the rise.

I had been brainstorming a few ideas for the next feature film I wanted to write and direct. After seeing Lucky through the lens, the story was downloaded to me in an

instant. It was a love story about two broken young teens that I had been toying with. Suddenly, I felt that Lucky should be playing the lead character. This came as a surprise to me as I usually go through a long auditioning process to cast actors AFTER I have written the script, raised the capital and am ready to film the movie.

I remember stopping for a moment and trying to figure out what was happening. It all caught me off guard, but the impression that I had of this young man in my new film was undeniable.

After the photoshoot, we went back up to the house and I told him and his family about the idea for this movie.

THERE WAS AN EXCITING ENERGY AND MAGIC ABOUT THE MOVIE FROM THE JUMP

Everybody loved it and we started brainstorming. It felt right and I knew that I had to make it happen. Lucky and his family were fully on board. There was an exciting energy and magic about the movie from the jump.

There were many doubters along the way. I'm sure people had just seen Lucky as a pretty face, but I saw much, much more. And I was right. He was amazing in the movie. Unforgettable. He has tremendous, natural acting skills and a humility that is rare for someone of his young age and level of fame. Lucky is different. He holds a special place in my heart. His looks are matched by his heart of gold. That's rare in this day and age. After growing closer to this young man and making a movie with him, it's no surprise to me that the world wants more of Lucky Blue Smith. I don't know if they can ever get enough.

At some point during all the preparations, I had to tell NEXT about the movie. I needed to take the entire month of August off during a very busy schedule and time in my career, which was absolutely not easy to do. Things were really heating up for me. I was getting busier and busier. And we knew NEXT was not going to be thrilled about me taking that much time off. When we finally told them, I was not surprised that they were against it. Not only the amount time, but against the whole idea of a movie.

One day my parents were in a meeting with Alexis and Mimi to talk about the movie. They did their best to

I REFUSE TO MAKE DECISIONS
BASED ON FEAR

discourage us from doing it. They both said it would be a huge mistake, and would ruin future opportunities to be discovered by big important directors and film-makers. They also said that if the movie was bad or I didn't do a good job, the film couldn't be buried or hidden because of the Internet and especially my social media following.

All I knew was that I really wanted to do it. To me, it felt good, and felt like the right thing to do. Everything they were saying sounded like it was coming from fear. I refuse to make decisions based on fear. My dad understood how I felt, and had the same feeling as me. He had to take a pretty strong stance and tell Mimi and Alexis that the film was going to happen no matter what. I knew that I might miss out on

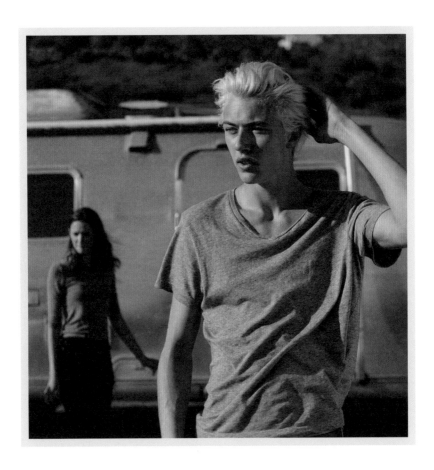

some great jobs during filming, but that was ok. I loved the idea of doing a movie with a good, inspiring message. I really appreciated my dad supporting my decision and going to bat for me. I realize that not everyone will understand or agree with you when you want to do something but, if it feels right and it doesn't hurt anyone, then you always need to listen to your gut and follow your heart.

After finishing the script, raising money, casting the actors, and arranging all the details, we were ready to go. The entire film was shot in the month of August 2015 with about 95 per cent shot in Utah, and the last few days in Malibu, California. Because it was a small budget independent film, the crew wasn't very big, but they were amazing. The days started early and ended late. Everyone worked really hard. As for me, I just listened to Rob and took it scene by scene. He made it easy and fun. We also started a new filming tradition of throwing a football around between scenes. One of the best ideas ever.

When my mom came to the set for the first time, she asked me how it was going. I told her it was the funnest thing I've ever done, and I loved every bit it. After filming *Love Everlasting*, I immediately wanted to do more. Acting is in my blood now and is something I hope to do for the rest of my life.

ACTING IS IN MY BLOOD NOW
AND IS SOMETHING I HOPE TO DO
FOR THE REST OF MY LIFE

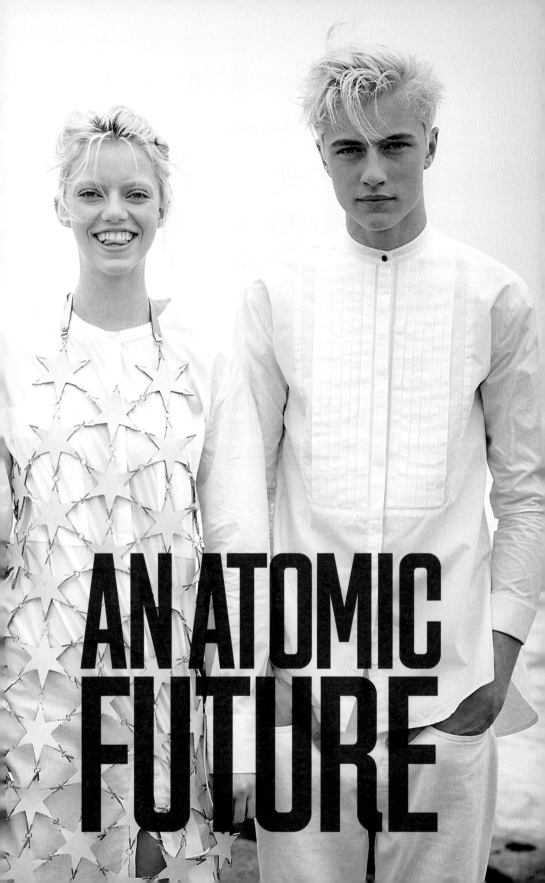

AN ATOMIC
FUTURE

Moving to California was a big and difficult decision. Well, it was an easy decision for me and my sisters, but for my parents it was pretty tough. Yes, it looked like there was great potential for modeling jobs and all that, but seeing what could happen with music was just as important to my family. We all felt like there was, and currently is, good potential with The Atomics, but it's going to take a lot of work, good timing, and good connections. We also feel like one thing we are up against is that we are models. And how can models really stack up in the music world? Like, 'Ohhh how cute, the models wanna play music, too. Can they really play? Is it just a show?' It does feel like a little bit of a target on our backs,

IT'S GOING TO TAKE A LOT OF WORK, GOOD TIMING, AND GOOD CONNECTIONS

but that's cool. I'm sure we'll be fine. We just have to work hard and prove ourselves in the music world also.

NEXT always believed in the potential of The Atomics. They took it seriously and landed us many great opportunities for jobs and publicity way beyond our modeling work. We've been lucky to have incredible articles and photoshoots for big magazines and websites because of NEXT. They also helped us make a great connection with ICM, which is looking very exciting for the band.

Then in August 2015, I met Emily Procter while working on *Love Everlasting* in Utah. We got along really well, and she got to know my family a little bit. One day she was

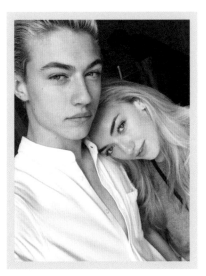

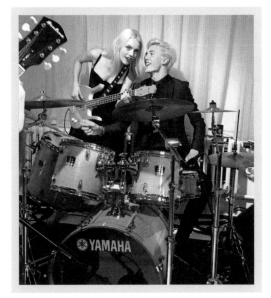

talking to my dad and said that she wanted to introduce us to someone who, if he was interested, could be the perfect manager for me and my family. She said his name was Simon Fuller, and she would try and make an introduction soon.

Well, we Googled Simon that night, and, of course, found out that he was beyond next level. It would be more than incredible to meet him, we all thought. A couple weeks later we had an Atomics gig at the La Mer 50th Anniversary Party in Hollywood. It was such a fun show. We invited Emily but she was going out of town and couldn't make it. She said she would ask Simon if he wanted to go. Based on what we had learned about Simon, we didn't really imagine he would go, but a couple days later she called and said he was coming! She also warned us that we might not know he was there. She thought, most likely, he'd just watch a couple songs and then take off. We probably wouldn't get a chance to talk with him. We thought, well, even if that happened we would be so stoked. The day of the La Mer show, my dad got an email from someone in Simon's office asking if he could meet Simon out front to make sure he was taken care of.

Not only did Simon make it to the event but he watched the whole show and wanted to talk after. We found a quiet room in the building and he actually took about 20 minutes to talk to us. He had some great thoughts and feedback about what he had seen and how we played. Then he asked us if we would come by his office next week so he could get to know us more. Uhhhh? We had no problem with that! He was so nice and fun to talk to. We couldn't wait for next week to come. Later that night, when we got home, we couldn't stop talking about how well the show went, and how amazing it was to meet Simon.

Our family always talked about what the future might bring for The Atomics, and we knew that we needed to take things to the next level. Our relationship was great with NEXT but, deep down, we knew that, as far as The Atomics went, we needed someone who specialized in music and managing artists. We were dying to meet with Simon and see what he was thinking, and to find out how interested he was in us.

The meeting with Simon could not have gone better. It was amazing and felt incredibly positive. He definitely wanted to work with us. He had so many inspiring things to say, and thought we had a great future ahead of us. Since our first meeting with Simon, we had other contacts offering to introduce us to other big names, A-level managers and music people. They all seemed like they would be incredible to meet with but, after talking to Simon, everyone in the family had a strong gut feeling that we should cancel all the other meetings, go with Simon, and never look back.

We are all so excited to see where this journey with Simon Fuller will take us. Up to this point, so many opportunities and blessings have come our way. It's been unbelievable. I have been so fortunate, and I am so grateful. I believe if we are smart, work hard, and stay focused, The Atomics can and will do great things. I can't wait to see what the future brings!

IF WE ARE SMART, WORK HARD, AND STAY FOCUSED, THE ATOMICS CAN AND WILL DO GREAT THINGS

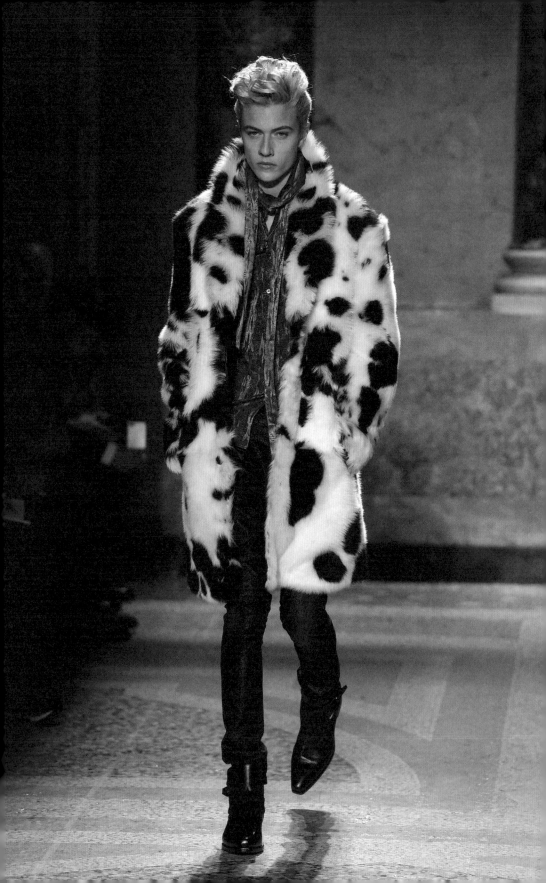

F ashion Week has been a huge part of my overall success in modeling. I started picking up jobs at the age of 14, but I was too young to hit the big fashion shows then. My age had something to do with it but, mainly, I didn't have quite the right body to fit the clothing. So, I had to wait a couple seasons before I could really do them. I finally did my first official show in January 2015.

I don't think I would have had anywhere near the success I've had as a model without being a part of Fashion Week. It's where you meet and work for all the biggest designers and people in the fashion industry. I don't know why they call it Fashion 'Week' because it lasts about a month but, basically, here's how it works . . .

There are two major men's fashion seasons per year, January and June. First, you start out in Paris for about a week of castings. Next, you go to London where the first half of the week is castings, and the shows are in the last half. Milan is pretty much like London with the week split into castings and shows. Then it's back to Paris for the shows.

My mom has always been my main Fashion Week buddy. Hardly ever do you see a model with their mom. For the first season, we were only planning on being there for three to four weeks, but we ended up staying for about six weeks. The NEXT Paris office had lined up a couple editorials and a few jobs at the last minute, so we tried to cram them in before we left for home. And, let me just say, we were so ready to go home after the first season. Living out of a suitcase for a month sucks. Both my mom and I were ready to burn the clothes that we'd been wearing over and over and over that whole time. But I'm very thankful she was with me. It was challenging, fun, and stressful.

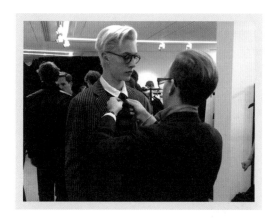

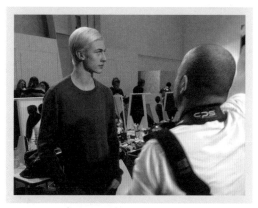

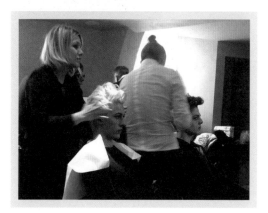

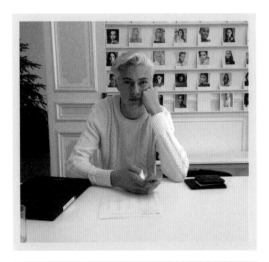

TOP: CHECKING IN AT THE AGENCY OFFICE IN PARIS. OUR LUGGAGE
GOT LOST ON MY FIRST TRIP TO PARIS AND WE DIDN'T HAVE IT FOR
TWO DAYS. I HAD TO BUY A FEW THINGS TO GET BY. IT FINALLY
SHOWED UP THE NIGHT BEFORE WE LEFT TO GO ON TO LONDON.

BOTTOM: ME CHILLIN' AT THE AIRPORT IN MILAN – MY FAVORITE
FASHION WEEK CITY. WE CAME STRAIGHT FROM THE CAVALLI SHOW
– YOU CAN TELL BY LOOKING AT MY HAIR. MY MOM WENT TO GET US
SOME SNACKS AND BOUGHT A MAGAZINE WITH ME ON THE COVER:
IT'S IN THAT BLUE SHOPPING BAG.

One of my favorite moments was riding a Ferris wheel with her in Paris and Facetiming the family at home.

I rarely get nervous about doing something new, but my first fashion season was a little intimidating. It's serious business and very fast paced. You have to be on top of everything. It was also stressful because, at the time, we were still very tight on money and traveling all over Europe with planes, trains, hotels, cabs, and restaurants can get very expensive. The six-dollar Cokes can really add up. We had to be very careful. Runway shows do not pay very much money. Most models just hope to break even at the end of the season. You really do them to be seen and hopefully book a campaign in the months that follow.

I RARELY GET NERVOUS ABOUT DOING SOMETHING NEW, BUT MY FIRST FASHION SEASON WAS A LITTLE INTIMIDATING

Fashion season is a grind. Yeah, I know, the fashion industry is cool and glamorous and all that, but it's a lot of hard work and it's exhausting to always be 'on' all day long. I know, I know, I'm sure people reading this will have a hard time wrapping their mind around the idea of modeling being 'hard work', but unless you have actually done it, it's difficult to understand. Imagine going to 12 job interviews every day. It can get exhausting. Castings are spread out all over a city with endless lines of guys that are just as good looking as each other. Casting directors are usually nice, but hard to read. You have no idea if you're going to get the job or not. That is why I had to learn not

to care. You have to hit the casting, and then just let it go. And when you're in the middle of a freezing cold January in Europe, walking around looking for addresses with a map, you start missing southern California in a big way.

Mimi would call me and give me feedback from certain designers. A lot of the time I was 'too this' or 'too that' for one casting director, and then not enough for the next one. Basically, with fashion shows and runway, you are literally a clothing hanger for the designer. I'm sure your face has something to do with it, but the bottom line is – does the model make the clothing look good and do you fit the whole vibe of the show?

The first season was a lot of pounding the pavements and learning the ropes. There was lots of rushing around, too. In Milan, I remember hitting the ground sprinting. I got off the plane and raced straight to a couple big castings. I was so exhausted at the end of each day it was unbelievable. My mom was wiped out, too. We found our favorite pizza in Milan just down the street from our hotel. Sometimes we'd hit that place twice a day.

I was a rookie, but I still landed some amazing shows my first time around. I had always wanted to try a new hair color, so the NEXT LA team suggested I try bleaching my hair again, like I had done for the *Interview* magazine shoot with Mikael Jansson. They thought it would give me an edge and make me look a little older. A little less 'Apple Pie', as Mimi would say. And it was a good move. It turned out that the platinum blond hair became a big signature for me. It made me stand out, and everyone took notice.

That first season was also special to me for a few other reasons. I finally got the chance to meet each of my NEXT agents from around the world for the first time. They

became my family across the globe. My mom and I were surprised to hear that the NEXT Paris, Milan and New York offices had no men's division – I was the only male model in those three offices. It felt special to know they were going to rep me as the only guy on their books.

With my second and third seasons, a lot of other things changed. I gained a lot more momentum. I was building relationships with people in the industry, and I think people respected me a little more as a model. There were definitely some nice perks that came with the success. I found myself not having to wait in lines sometimes. Occasionally I'd walk into a room where guys were waiting in line and someone from casting would come up to me and say something like, 'Hey, Lucky, come with me. You don't need to wait.' It felt kind of weird to cut in front of the other guys, but I got over that.

THERE WERE DEFINITELY SOME NICE PERKS THAT CAME WITH THE SUCCESS

For some reason, my mom couldn't go with me to the second season so we asked our old family friend Pete to take the first half of the season and Daisy took the second half. Toward the end of his stay, Pete realized that his half was the grind half – nothing but running around to castings and hitting the pavements. He'd say, 'Hey, I'm doing all the grinding-it-out, non-fun stuff, and Daisy gets to stroll in and go to all the shows with the glitz and glamour. How did that happen?!' Pete was great, though. I'm really glad he came. We had a lot of fun together.

Here's how Pete remembers those crazy days:

PETE ANDERSON Lucky has a handful of older buddies who've been around from day one. And when I say 'day one', I mean the very moment in 1988 when Lucky's mom and dad locked eyes on a dance floor for the first time. I was there the night Dallon got up the nerve to ask Sheridan to cut a rug. One slow dance to 'Careless Whisper', and Lucky's genetic lottery ticket was in hand. As the family welcomed Starlie, Daisy, Pyper, and finally Lucky, I took on the honorary title of 'Uncle Pete', and have had a front row seat at the Lucky Show ever since. That's how I ended up as Lucky's chaperone across Europe in 2015, essentially shadowing him through London, Paris, Milan and eventually Stockholm. Sure, I'd seen video clips of Lucky's Beatlemania meet ups but I was about to see this infatuated pandemonium first hand and up close.

All the international teen heartthrobs of my day had to be published or broadcast, presumably picked by some taste-maker and offered up to the masses: *Tiger Beat* photos splashed with graphic hearts (before emojis even existed), a sugary pop song repeating on MTV. Some Hollywood idol-maker in a suit had to discover you, coach you, and give you your 'big break'. The idea that Lucky could build a global fan base armed with only an iPhone and a couple of photo filters seemed impossible to a Generation X guy like me, but I was about to graduate from Millennial School.

We first encountered Lucky Charms (what Lucky's fans have dubbed themselves) when we checked into his Paris agency. We'd hardly got hold of his list of appointments for the day when we were informed that there was someone waiting to see us in the lobby. That someone turned out to be half a dozen die-hard fans: giddy, smiling girls who, in addition to ditching school, must have done some deep

Internet sleuthing to discover Lucky's whereabouts –
he hadn't tweeted a peep. I sort of get how TMZ gets tips
but these gals are working on another level.

Before long, I began to realize that, to most Parisians,
Lucky was just another lanky, pretty-boy model walking
the streets during Fashion Week, but to a certain 'cusp of
adolescence' demographic, bumping into Lucky was as
surreal and magical as having Siri appear in the flesh, like
having their iPhone come to life. Before long I could spot
the reaction before it even happened. We'd be crossing the
street towards a squad of schoolgirls headed home in the
afternoon, backpacks flung over their shoulders, their faces
buried in their smartphones. One would inevitably glance
up and see Lucky's shock of platinum hair and, given her
reaction, it must have been the same image she had on her
screen. Her brow would furrow, a quick squint to focus and

then her eyes would expand into saucers. Unable to contain her amazement or avert her gaze, she would reflexively elbow jab her nearest friend, as if to get confirmation: 'Yo, yo, yo, are you seeing what I'm seeing?'

Lucky and I would pass them by, seemingly unaffected. We'd stop at the next corner to check the map, and I'd say something like, 'Hey, cowboy, I think you got spotted.' We'd pause at the corner, place a little side bet on whether they'd muster the courage to come over and ask for what they all wanted, the gold standard in social media currency … a selfie. Combatting shyness and giggling, they'd doubleback towards us and utter the increasingly familiar phrase, 'Are you Lucky?' And I'd shake my head and think, 'Truer words were never spoken.'

By law there's a pamphlet in every Vegas casino called 'When the Fun Stops', presumably to help addicted gamblers come back to reality after losing it all. Sitting in the Charles de Gaulle airport about to board our plane to Stockholm, I realized that, without risking much, Lucky's chips were stacked so high in front of him it may be hard for him to see this early success as a windfall that should be socked away for the future. As white-hot as his modeling career was, his sky-rocketing fame and fortune could just as quickly fade in the years ahead. So, with a healthy degree of cynicism, I did what most washed-up, slightly jealous, middle-aged men would do, I warned him about the pitfalls of life: girls that might like you for the wrong reasons; 'You'll die doing what you love … if you love texting while driving'; the very real need to save ALL your money. Basically the routine advice any adult tries to drum into a teenage boy's thick skull.

But the thick skull belonged to me.

Somewhere between my animated hand gestures, the spicy personal stories and all the back-and-forth, both Lucky and I realized we'd lost track of time and completely missed our flight to Stockholm. My one job was to get him on that flight and I blew it. From then on it was a game of planes, trains and automobiles. Scrambling about, we searched every conceivable flight, every train schedule, even looked into renting a Porsche and driving through Germany's *autobahn* all night long. But without a viable option, we slowly admitted defeat and had to call his client and tell them we'd be late for the next morning's photoshoot. So unprofessional. Such a bone-head move. I was mortified. I'd never missed a flight before in my life. But because Lucky is indeed lucky, a few phone calls to the client to push back the call time and our nail biting ceased.

The chance encounters in Paris were one thing, but I truly understood the scope of Lucky's social reach when we had a meet up in Stockholm. Lucky had never tried one in Sweden before and we didn't know what the address would be until we checked into our hotel, so there was only six hours' notice between the Instagram invite and the actual event. We didn't have any way of gauging whether anyone would show up, so we got ourselves mentally prepared for the possibility that it would be just us and a bellboy. We thought it would be a win if we met a dozen or so really dedicated fans.

I had Lucky wait inside the lobby while I chanced a peek outside to see what we were in for. I turned back to Lucky, a huge grin on my face, and told him to wait a second. I needed to get my phone out to record this for posterity. Lucky took a deep breath and then we marched out into the late-evening Scandinavian sunlight.

A mob of girls was waiting for him, lined up in surprisingly orderly fashion along the opposite sidewalk. Lucky motioned to them that they could come over and, like a swarm of hormonal alarm clocks synched up, they screamed and squealed and flooded into the street.

I soon learned that, if you're going to shadow Lucky during a meet up, you need to come prepared. First, you need endurance. Lucky doesn't turn anyone away. As long as there is someone who wants to take a selfie with him, he's at his or her disposal. Second, you have to be ready for presents. Lots of Lucky's fans have an artistic streak, and they like to present him with drawings they've done of him. Last, you need to be prepared for a crush. You're dealing with a sea of howling, tear-stained faces, and the ocean crashes in waves.

Often, Lucky's clothes already have a lot of holes in them. That just gives his adoring fans a handhold to lock their fingers into. By the end of our Stockholm experience, his shirt was the worse for it, some of the holes having turned into gaping tears. I told Lucky to just let them have it, so he tore it off and tossed it into the crowd like a bridal bouquet. There were no casualties in the scrum that ensued, and the victorious combatant went home without her feet touching the ground.

It's easy to dismiss the Lucky Charms as silly but they're not. Watching and talking to them you realize they share a real togetherness. Social media isn't really social until it unites people in real life. These girls have this big communal thing that they all know and love and understand – in a way, Lucky belongs to them. They're all in it together. And I know Lucky knows just how lucky he is for each and every one of them.

THIS IS ONE OF THE CARDS THAT ARE BACKSTAGE WITH YOUR LOOK. THE NUMBER IS WHERE YOU ARE IN THE SHOW. THEY TAKE PICTURES AT THE FITTING TO MAKE SURE THE DRESSERS GET THE LOOK PUT TOGETHER JUST HOW THE DESIGNERS WANT THEM.

A s Pete set off home, Daisy tagged in. It was her first time in Europe, and we had a blast together for two weeks. By that time I pretty much knew what I was doing and how to get around. I was more comfortable going places and exploring the cities. As Pete predicted, Daisy went to all the cool shows with me and met a lot of great people. She also met all the agents at each of the NEXT offices in Europe. Which, by the way, directly led to us booking an awesome campaign together for Mavi in Istanbul. One day we did a meet up together in Paris. For some reason, this meet up was seriously off the hook crazy.

We couldn't believe how many people showed up. But what was even crazier was that girls were pinching Daisy and pulling her hair behind her back. Maybe they didn't know she was my sister, and thought she was my girlfriend or something.

Overall, the Fashion Weeks have been great and I've learned so much. It's so impressive to see how much goes into creating some of the big events and shows. I'm sure I'll continue to be involved with them. It's probably impossible to calculate all the opportunities and good things that have come from them. I landed incredible shows and met the most influential fashion people on the planet.

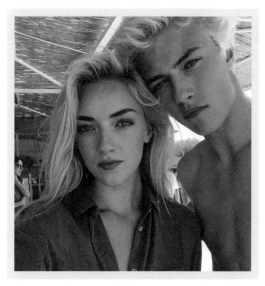

DAISY AND I GOT TO GO TO ISTANBUL TOGETHER TO SHOOT FOR MAVI JEANS. WE HAD A LOT OF FUN EVEN THOUGH IT WAS A QUICK TRIP. I REALLY LOVE WORKING AND TRAVELING WITH MY SISTERS.

It's difficult, if not impossible, to say which has been my favorite fashion show. I have been very fortunate to get all the shows I've booked. Each of them has been important to my career and I have enjoyed them all. But if I had to say which was the most exciting, crazy, and fun, I'd have to go with Philipp Plein. In my second season, I was given the huge opportunity to open their Spring/Summer show. And that show was off-the-charts cool. In the midst of monster trucks, cars racing, motorcycles jumping, fires, explosions, and pure mayhem, I came riding out standing on the back of a motorcycle.

WHO WOULD HAVE THOUGHT I'D BE IN THE WALL STREET JOURNAL?
IT WAS CRAZY TO SEE THAT ARTICLE COME OUT. IT GAVE ME A
WHOLE NEW PERSPECTIVE ON MODELING AND THE THINGS I'VE DONE.

I HAVE BEEN ABLE TO WORK WITH CARINE ROITFELD A FEW
TIMES. THE FIRST TIME WAS ON A TOM FORD SHOOT - SHE
THOUGHT I LOOKED LIKE A YOUNG CHRISTOPHER WALKEN AND
WANTED TO DO AN EDITORIAL WITH ME AS CHRISTOPHER WALKEN
FOR HER VERY FIRST ISSUE OF CR MEN'S BOOK. IT WAS COOL
TO BE ON THE COVER AND PART OF THE FIRST ISSUE. SHE IS
ONE OF THE BEST PEOPLE TO WORK WITH - SHE IS EASY TO
TALK TO AND ASKED FOR MY OPINION ON THINGS. SHE WAS KIND
ENOUGH TO INVITE ME AND MY SISTERS TO A DINNER PARTY SHE
HOSTED IN NEW YORK. THIS PICTURE WAS TAKEN AFTER A LONG
FASHION WEEK. YOU CAN CLEARLY SEE HOW TIRED I WAS.

LUCKY BLUE SMITH
FALL/WINTER 2015

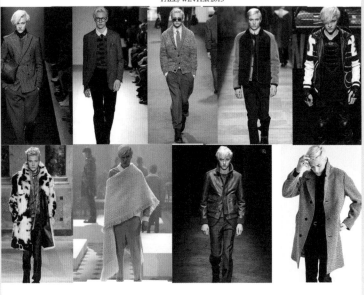

Bottega Veneta
Dunhill
Etro
Fendi
Philipp Plein
Roberto Cavalli
Sacai
Salvatore Ferragamo
Tom Ford

NEXT

Breaganta Men's Shows Fall/Winter 2015

Lucky Blue Smith
FW15 Show Report
NYC

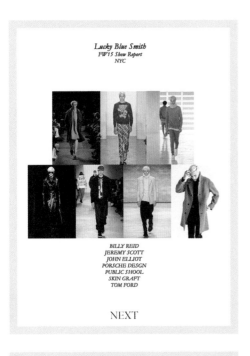

BILLY REID
JEREMY SCOTT
JOHN ELLIOT
PORSCHE DESGN
PUBLIC SHOOL
SKIN GRAFT
TOM FORD

NEXT

Lucky Blue Smith
FW16 Show Report

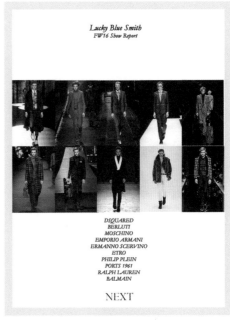

DSQUARED
BERLUTI
MOSCHINO
EMPORIO ARMANI
ERMANNO SCERVINO
ETRO
PHILIP PLEIN
PORTS 1961
RALPH LAUREN
BALMAIN

NEXT

Lucky Blue Smith
SS16 Show Report

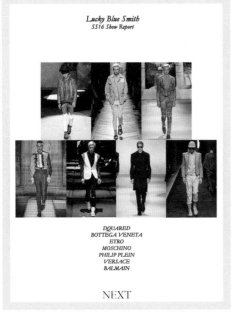

DQUARED
BOTTEGA VENETA
ETRO
MOSCHINO
PHILIP PLEIN
VERSACE
BALMAIN

NEXT

Lucky Blue Smith
SS16 Show Report
NYC

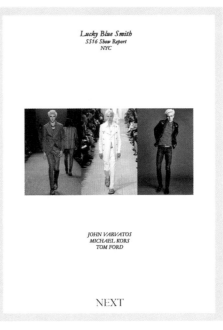

JOHN VARVATOS
MICHAEL KORS
TOM FORD

NEXT

GQ
COVER

here I was, walking out of a gas station food mart with an ice-cold can of grape soda and a bag of my favorite Takis when my phone rang. It was Mimi. She said, 'Hey, where are you right now?' I told her I was at a gas station in Culver City. 'Good, because I want you always to remember exactly where you were and what you were doing when you first found out you are confirmed for the cover of *GQ*!'

Mimi had been working on getting me the cover of *GQ* for a while, but there was another chain of events that had happened in the previous months that helped make it happen. And, of course, Mimi was driving those, too. I had worked on a smaller job for *GQ* before, and was very lucky to get to know them and start a relationship. In November 2015, *GQ* had hired me for a really cool David Bowie inspired editorial. I loved that shoot – I loved the clothes, I loved everything about it. We shot it in an old part of Brooklyn in a studio and then at an old record shop near by. The finished editorial was awesome and it came out in the January 2016 issue.

Meanwhile, around Christmas, about a month after the David Bowie shoot, *GQ* ran a voting showdown for the 'Most Stylish Man of 2015'. People voted online from all over the world. On paper it looked like a sports knock-out tournament. They had me going up against Ralph Lauren right out of the gate. Immediately I thought, 'Well, that was nice to be in the contest for 15 seconds.' But somehow I beat him and moved on to the next battle against LeBron James. When I then beat LeBron, I was thinking, 'What is going on?!' By this time, I was getting a lot of messages from friends and family telling me they were voting for me. You could tell there was a real buzz going on. At this same

time, my family had just left for a New Year's Caribbean cruise – we had decided to trade presents for a vacation to make some memories. Somehow I made it through Bradley Cooper and David Beckham – I don't even know how that was possible, but it happened. I was beating guys that I had no business beating. I couldn't believe what was going on. When I got through against Robbie Rogers, it was just me and Kanye West left competing for the number one spot. Internet access on the cruise ship was terrible, so it was hard to check on the status but it seemed like a tight race. The night before the contest was over, I went to bed as number 1. When I woke up, Kanye had beaten me. But that's ok, I was blown away by how far I got. It was so cool to watch it all unfold. It was after all that I landed the cover of the May 2016 GQ – before I had even turned 18. Absolutely amazing.

I found out later from Mimi that Victoria Graham, the bookings director at GQ, and Jim Moore, the editor, had personally pushed for me to be in the magazine. I learned that GQ no longer featured models, but instead favored celebrities for every issue. It turns out that before my GQ cover came out, the last male model to be on the cover was about 14 years ago.

I DON'T EVEN KNOW HOW THAT WAS
POSSIBLE, BUT IT HAPPENED

PEOPLE
AND PLACES

The first time I went on a casting for Tom Ford it was in London for Fashion Week in January 2015. My mom was with me and wanted to take my picture – I have to tell you I really wasn't into it, but I'm happy I have it now. I really appreciated and enjoyed working with Tom. I have done a few shows and campaigns with him since then and he knows what he wants but is always very nice and dresses like a boss. He has dressed me for many events and I always feel effortlessly cool and on point. I've gotten spoiled with being given amazing things to wear so I thought why not ask if he could send me a tux to borrow and wear to my senior prom – and he did. How freaking cool is that?!

shot my second Tom Ford campaign where I danced most of the day and then my mom and I headed to LAX for an evening flight to London for the Business of Fashion awards dinner. The BOF is a nominated list featuring the 500 most influential people shaping the global fashion industry in each year. It was shocking to think I had been named on that list in 2015. I was just a 17-year-old kid having fun and traveling the world, modeling and being myself. When we got to the hotel we showered, got dressed and headed for the dinner where all kinds of fashion industry people were. I had an interview the next morning in the hotel lobby and then, just like that, my mom and I were back on a plane going home. It was literally a 24-hour trip. It's that kind of traveling here and there for a minute or two that made me fill up an entire passport in only eight months.

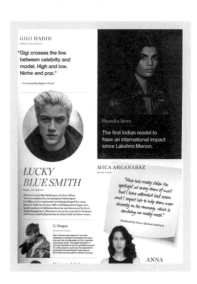

THE COVER ART WAS DONE BY AN INSTAGRAM ARTIST NAMED @UNSKILLEDWORKER.

219

I have had the opportunity to work for the Hilfiger brand several times. We worked together in Amsterdam, LA, and New York. We've done several projects together – campaigns, look books, and shows. Knowing the history of the brand and all that they have done made it exciting to meet Tommy and work for them. I have a great denim Hilfiger jacket that I like to wear. I have a slight obsession with jackets and this fits into my collection very nicely.

On my first trip to London – it was a quick trip on my way to Amsterdam to shoot for the Tommy Hilfiger brand – I was walking through customs with my mom and they told us people were waiting for us outside. We told the customs people that it must be for somebody else. Both my mom and I were so stunned when the customs doors opened and tons of girls were screaming my name. We were in shock and could hardly believe it. We were not even close to expecting this at all but it was fun.

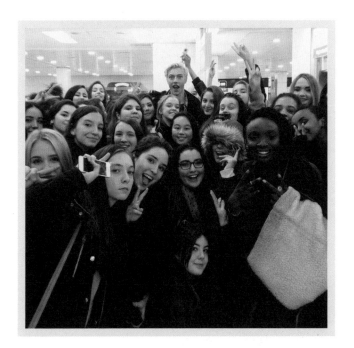

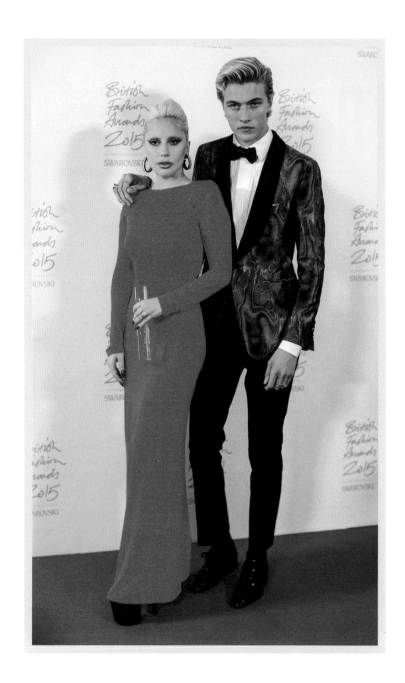

What a huge honor this was for me to present, with Lady Gaga, The Red Carpet Award to Tom Ford. I made this quick trip to London and was blown away at what a big deal it was. The red carpet event was amazing and the paparazzi were swarming. I got to sit at one of the big fancy dinner tables surrounded by people who were a lot more important than me. I had a blast hanging out with Lady Gaga! But I gotta say, being chosen to present the award to Tom Ford seemed a little out of my league. It was kind of humbling, because my little social media following and stack of tear sheets pale in comparison to Tom Ford's accomplishments. But, that being said, I was thrilled to do it and had such a great time.

I LOVE FISH AND CHIPS. I ALWAYS HAVE AND ALWAYS WILL. THIS DAY WAS HISTORICALLY IMPORTANT – I CHOWED DOWN ON REAL FISH AND CHIPS IN REAL LONDON. FISH AND CHIPS + LONDON + ME = TRUE LOVE.

t's kind of crazy to see yourself in store windows, or have your friends and family send you pictures of places they've seen you. But it's also pretty dang cool. I'm so grateful to have the opportunities I do – I love it.

Another crazy thing to think about was me getting the Male Model of the Year at the Elle Style Awards in 2016. Rosie Huntington-Whiteley was the presenter, which I was pretty excited about. It was the first time I'd had to go on stage to accept an award and, once I got up there, I was pleased I'd gone over my thank you in the hotel with my mom. I like to wing it usually but I was glad I'd thought about it. When we headed home, my mom packed the award in a carry-on bag wrapped up in some clothes for safety. We got held up at security because it looked strange on the monitor, I guess, and we almost missed our flight. Now I have the award on a shelf in my room.

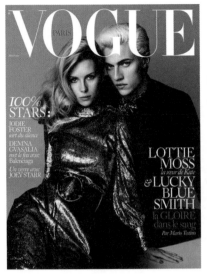

VOGUE *PARIS*

100% STARS:
JODIE FOSTER *sort du silence*
DEMNA GVASALIA *met le feu avec* Balenciaga
Un verre avec JOEY STARR

LOTTIE MOSS *la sœur de Kate* & LUCKY BLUE SMITH
la GLOIRE dans le sang
Par Mario Testino

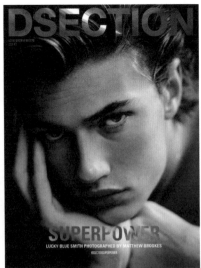

DSECTION

SUPERPOWER

LUCKY BLUE SMITH PHOTOGRAPHED BY MATTHEW BROOKES

#DSECTIONSUPERPOWER

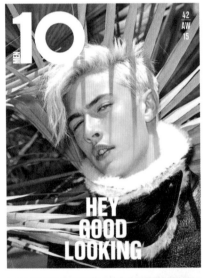

MEN **10**

42 AW 15

HEY GOOD LOOKING

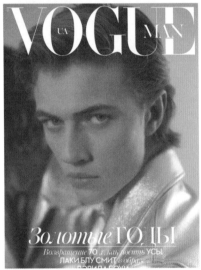

VOGUE UA MAN

Золотые ГОДЫ

Возвращение 70-х годов: носить усы
ЛАКИ БЛУ СМИТ *в образе*
ВЭРИДА ГОУ

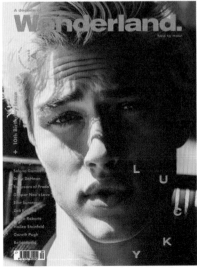

A decade of W**onderland.** *then to now*

+ 10th Birthday Issue

Selena Gomez
Dree DeHaan
The years of Prada
Elliot Summer
Gaspar Noe's Love
Zoe Kravitz
Emma Roberts
Hailee Steinfeld
Gareth Pugh
Katharine...

L U C K Y

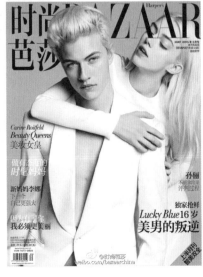

Harper's **BAZAAR**

时尚
芭莎

MAY 2016

Carine Roitfeld
Beauty Queens
美妆女皇

做有格调的
时髦妈妈

新妈妈李娜
下台不
自己更强大

因为自主自强
我必须更美丽

孙俪
不屈 充满着
评判过程

独家抢鲜
Lucky Blue 16岁
美男的叛逆

时尚芭莎
weibo.com/bazaarchina

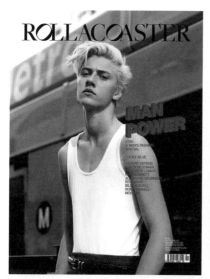

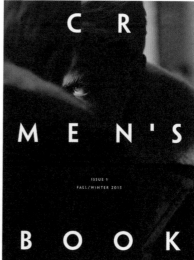

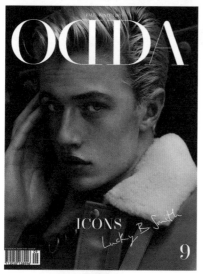

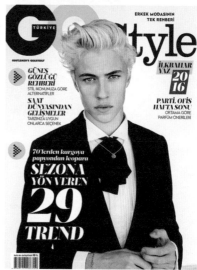

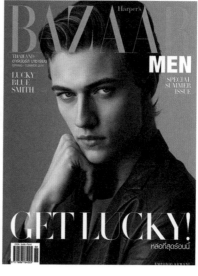

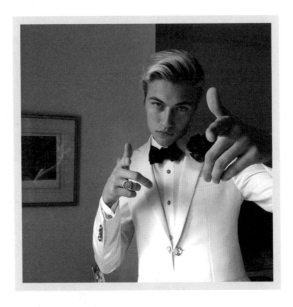

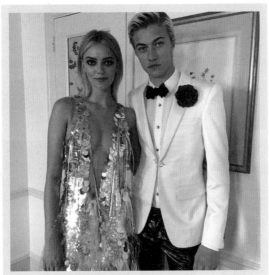

Pyper and I were invited to go to the Met Ball by H&M. I didn't know too much about it except that it was a pretty big deal. Pyper and I met with H&M and got to collaborate and have our looks custom made. There is a different theme every year and all the looks and designs are meant to go along with the theme. This year it was 'Manus x Machina: Fashion in an age of Technology'. I had really cool crackle leather pants in a dark blue that I really liked. Pyper's dress was silver and chrome looking but she said it was light, comfortable and very easy to wear. H&M really did make us incredible things to wear. Pyper and I met in New York and got to stay in a great suite together. We arrived to all kind of goodies that were waiting for us, including robes with our names embroidered on them. The people at H&M are so kind and great to work with – they made it really special and fun. I still wear my robe at home – it's pretty dang cool. We got to walk the red carpet and mingle with lots of people. It was fun for me because since I have been able to work with so many great people and been to other events, now I feel like I know a lot of the people who are at these things. It makes it so much easier and more comfortable. Sometimes it's a little like a reunion because I get to see people I haven't seen or worked with in a while. I've been to events in the past by myself where I didn't know anyone. It gives you a nice little crash course on being outgoing, friendly, and working the room. These events make it possible to meet important new people. No one has fun or enjoys themselves by keeping quiet and staying out of the mix – you just have to get in there and go for it!

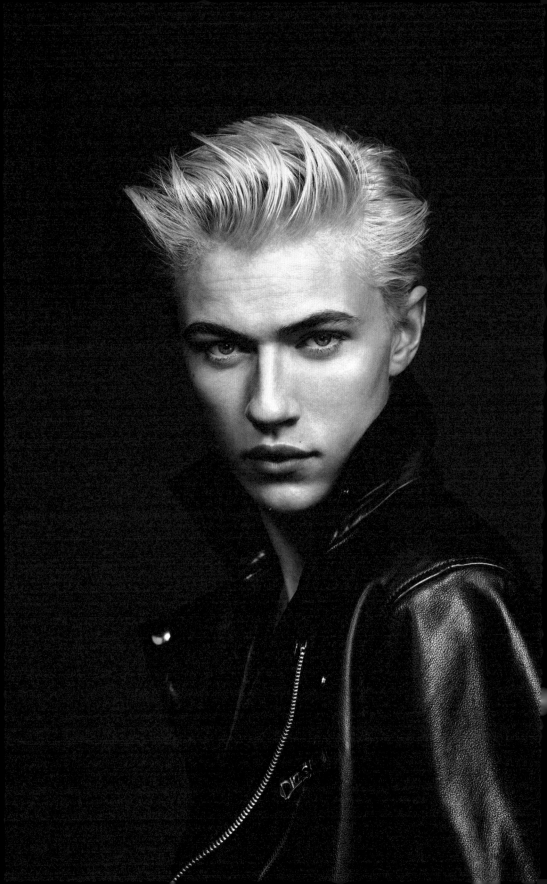

During the summer of 2015, I got a very surprising call from Mimi. She said we were going to meet with the president of L'Oréal, Cyril Chapuy, who was in Los Angeles on some kind of a shoot. At the time, I really thought of L'Oréal as a brand for women's products. I mean, I thought they had some men's products too, but I really didn't know much more than that. I was very excited to meet him, to say the least, because it was a big deal, but I was curious as to why he was interested in meeting me.

Mimi and I met up and drove to the shoot location together, a beautiful home in Beverly Hills. After waiting a bit, he saw Mimi and me and told us to come around the corner to a quiet part of the set. He told me all about L'Oréal, and wanted to know more about me and my whole story. We had a good meeting for about 15 minutes, then he had to get back to the shoot. Cyril was very nice and seemed like he wanted to work with me at some point.

A few months after we met, I heard that L'Oréal might be interested in starting to work together. At that time, all I really knew was that Mimi and Sebastien Tardieu, from the NEXT Paris office, were working on it to see what we could create with them. Mimi didn't want just a couple good jobs, she wanted more. She wanted a big contract. And after some back and forth with L'Oréal, what I thought might be great turned into something completely shocking and amazing. I was to become a real L'Oréal brand ambassador with a possible multi-year contract. I also heard I was to be their youngest ambassador. Unbelievable!

Before long, I was on a plane to Paris for a big three-day campaign shoot. They put me up in a huge fancy hotel, and I woke up to an early call time on the first day. We did everything – video, stills, interviews. It was absolutely

game on with no messing around. But the L'Oréal team made it really fun and enjoyable. At one of the studios they built a fake shower and I had to take a shower for their body wash commercial.

At another location there was a huge square swimming pool. We spent the rest of the day diving and doing underwater videos. On one of the days, the studio had built a set with fake rain. I played the drums in the rain. It was so crazy and fun! I had never done that before. After three full days of shooting my mom and I headed back to LA.

Another great thing about being an ambassador for L'Oréal is that I was able to go to the Cannes Film Festival. That was an unbelievable trip. The film festival was filled with shoots, interviews, parties, events and everything you can imagine that is cool. Celebrities were everywhere. It was very busy and everything was extremely planned out. Let's not even talk about how completely rad my hotel room was with insane views of the ocean. I have never been any place that had so many paparazzi – they were everywhere I went. They even hid in the bushes below my balcony. I fully enjoyed that trip and being at the festival, especially since I have become very interested in pursuing acting. I can't wait to do it all over again.

I PLAYED THE DRUMS IN THE RAIN.
IT WAS SO CRAZY AND FUN!

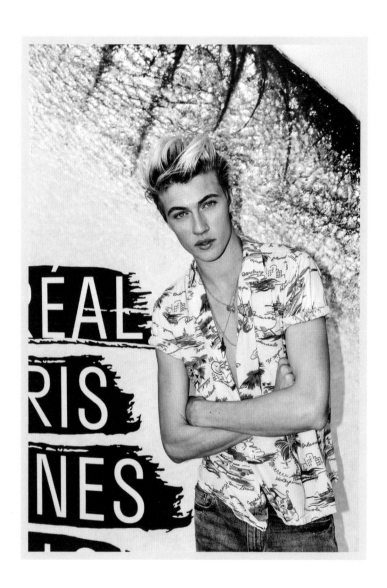

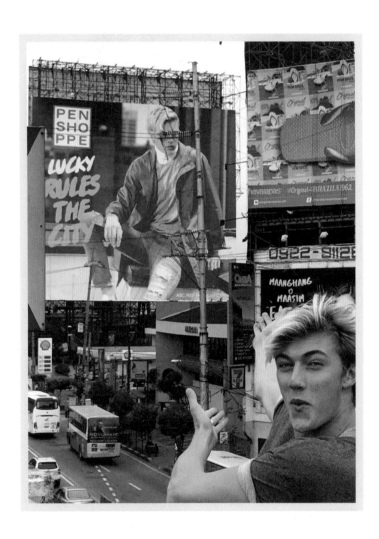

The Philippines! What a fantastic country and such great people. My dad grabbed this shot as we had about 20 seconds to stop traffic on a bridge and jump out of the van. This is the biggest billboard in the country. How cool is that?! I came to Manila to do some events for a company called Penshoppe. They're a fresh brand in Asia and definitely worth keeping your eye on. I had so much fun with them. Along with a fashion show called Cool Kids District, we did a huge event in the Penshoppe store and atrium at the SM Aura Premier mall. The turnout was next level insane. The amount of people and energy was off-the-charts crazy. They even had a drum kit on stage for me to play.

I was so impressed by how great the people and fans were in Manila. I really felt a lot of love from them, and I love them, too. I don't mind the word 'fans' but I'd rather think of them as friends. I really hope to spend more time in the Philippines. Thank you for such a great time!

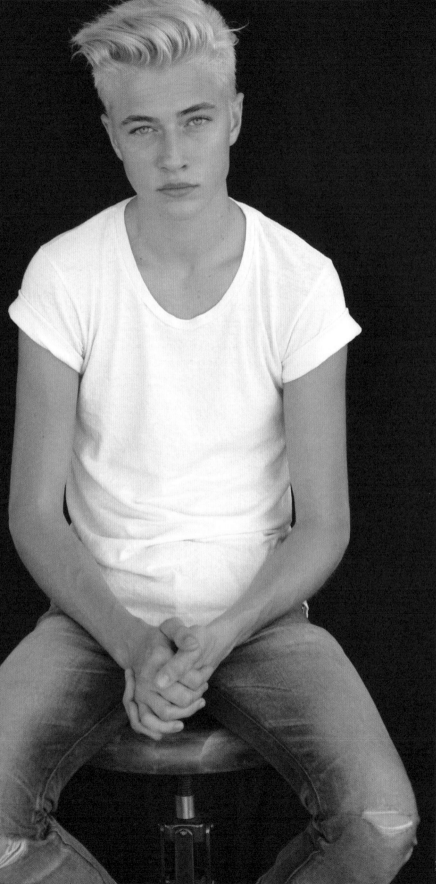

Thank you

Yes, currently I might be the hot new thing in the modeling and fashion world. And for the moment, I might have the right looks and moves and vibes going for me. And my timing may be just right, and people may say that I won the genetic lottery, but one thing I know for sure is that there is no way I could have achieved the things I have in my career without the incredible army of great people who have worked with me and played a crucial role in getting me to this place. There is no way in the world it would have happened without them.

I'm actually sitting here thinking, how can I even begin to list or name everyone? It seems impossible. And I would not want to leave a single person out. The last few years have been crazy going from one thing to the next. One fantastic opportunity to the next fantastic opportunity. One valuable contact to the next valuable contact. It's overwhelming and difficult to wrap my mind around it.

It's impossible to imagine the combined total of care, thought, creativity, energy, and hours from all these people who believed in me.

I have been with an incredible agency, NEXT. It hasn't just been in LA, it's been in Milan, Paris, London, and New York. I have an incredible global team. They've stayed up late and gotten up early to communicate in all the different time zones, they have worked together, sent thousands of emails, texts, chats, DMs, and made a zillion phone calls. They have made it fun, solved problems, hustled, and they haven't taken no for an answer. They've set up drivers,

planes, trains, taxis, and even taken me on castings when I'm in a new city, and given me rides between shows on Vespas. They've snuck me out of hotels and kept me safe at my meet ups. They've listened to my ideas and valued my opinions. They've let me be me and express myself and my style. They have absolutely rocked and helped me to achieve things that are groundbreaking and firsts. It has been a pleasure to be on this crazy ride with them. To my entire global team and all those who work on my behalf, thank you for all you do, you amaze me.

I also want to give a special thanks to Alexis Borges. You saw something in me and had a great vision from day one. You were always there for me and you always thought big and out of the box. Thank you so much for everything you have done. I will never forget it.

I have been so blessed to work with the incredible people at NEXT but I have also been lucky to work with all those people who decided to take a chance on a skinny punk kid who couldn't even fit in men's clothes for a few years. People who are incredibly creative in all areas of fashion. The list is full of world-renowned and insanely talented photographers, designers, magazine editors, stylists, groomers, colorists, casting directors, decision makers, lighting techs, digital techs, drivers, and dressers. I've met and been able to work with people who have inspired me and taught me new things. I don't know how I could come close to naming everyone who has impacted me and who I have had the pleasure to work with. But what I can tell you is that whether or not your name appears in this book, if I have worked with you, you have helped to get me where I am today. I hope I have treated you with respect, appreciation and inspired you in some way as well. From

the bottom of my heart, I am very, very grateful. Thank you for giving this inexeperienced kid a shot.

To my fans and Lucky Charms, I love you very much, and want to thank you for all the unbelievably great support you have given me. I've had so much fun with you. There are no words for how I feel. You have encouraged me, lifted me up, made me laugh, and you've made this journey so exciting. I truly hope I can be a good example and maybe an inspiration for you. Thank you so, so, so much for being there.

I am grateful to be able to work with ICM with my band The Atomics, CAA to pursue my passion for acting, and I'm especially grateful and super excited to be working with Simon Fuller and the team at XIX Entertainment. It's a new chapter with new trails to blaze and I am so stoked to be surrounded by the people I am.

Mostly I am so very, very thankful for the love and support my mom, dad, Starlie, Daisy and Pyper give me. I know I wouldn't be the person I am today and I wouldn't be where I am today without their support, help, sacrifice, keeping me in line, making sure I am on solid ground, and empowering me the way they do. I know that whatever happens, wherever I go, no matter what, my family will always love me and be there for me and I will always love and be there for them. Family is the most important.

I am excited for the future. I am ready to go for it and I promise to stay golden along the way.

With love,

Lucky Blue

Good things
I have learned in life

It is good to do things for people sometimes and not
expect anything in return.

When you shake someone's hand, always give them
a firm grip and look them in the eye.

Good manners will take you farther than you realize.

You can do anything in life if you have a good
plan and work hard.

You gotta hustle for things you want.

Confidence is everything.

It's ok to be in the world, but you don't have
to be of the world.

Prayers are answered.

You're always a teacher to someone. You can either
be a teacher of what to do or what not to do.

You should make standards for yourself and keep them.

Never be afraid of standing up for what you believe in.

Do good, get good; do bad, get bad.

Money will never make you happy.

Family is very important.